SETS, SERIES
&
ENSEMBLES
IN AFRICAN ART

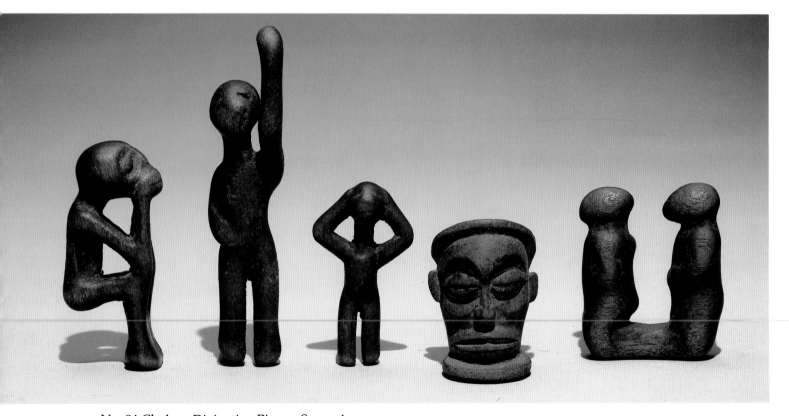

No. 84 Chokwe Divination Pieces. See p. 4.

SETS, SERIES
&
ENSEMBLES
IN AFRICAN ART

George Nelson Preston

Introduction: Susan Vogel

Catalogue: Polly Nooter

THE CENTER FOR AFRICAN ART, New York

Harry N. Abrams, Inc., Publisher, New York

To my teachers Douglas Fraser,
Hans Himmelheber, Albert Radoczy,
William Spinka, Stuyvesant van Veen, & Paul Wingert
& to Eva L.R. Meyerowitz

Jacket illustration and page 2
No. 84 *Divination Basket*
Angola, Chokwe
Mixed media D. 14in.
Cecelia and Irwin Smiley Collection

Chokwe divination baskets provide a typical example of an ensemble in African art. The diviner shakes a covered basket after invoking the spirits with a rattle, and then interprets the fall of the figures and objects that rest upon the rim. Each small object and wooden figure carries a positive or negative connotation; the figure with its hands to its head refers to death, since it represents a mourner, while the crouching figure, a male ancestor, alludes to power, youth, and intellect. Like words in a sentence, these figures, in juxtaposition, convey meaning; they explain, guide, or cure. The fragments of clothing attached to the rim have been left, according to custom, by clients cured through divination with this basket. (*Sources for no. 84; Bastin 1982; De Areira, 1978*).

Photographic Credits:
Lynton Gardiner: Objects 1, 14, 16, 24, 25, 34, 36, 63, 68, 72, 76, 79, 80, 84 and 85; Eric Politzer: Objects 2 and 3; Jerry L. Thompson: Objects 4, 5, 8, 55, 82 and 98; Robert Wallace, Indianapolis Museum of Art: Objects 9 and 10; Margaret Landsberg, Belmont, Massachusetts: Objects 11 and 27; Gerald M. Hoffman: Object 15; Photographie Studio Contact, Paris: Object 22; Jeremy Sundgaard: Object 26; The British Museum: Object 42; Ken Cohen Photography: Objects 43 and 81; Sato Photography: Object 49; Photograph Services, The Metropolitan Museum of Art: Objects 54 and 59; Jean Wagner: Object 65; Art Gallery of Ontario: Objects 71 and 77; Charles Uht: Object 78; Taylor and Dull: Object 87; Robert Lang: Object 92; The Portland Art Museum, Object 57; Smithsonian Institution Museum of Natural History Photographic Library: Object 88; Courtesy of Sotheby's: Object 86; University of Michigan Museum of Art: Object 67; University Museum, University of Pennsylvania: Object 75.

Design: Maria Epes
Production Coordinator: Lynn Landy
Index: Jeanne Mullin
Photography: Lynton Gardiner

Printed and bound in Japan by DAI Nippon
Library of Congress Catalogue Card Number: 85-7791
ISBN 0-8109-16371

THE CENTER FOR AFRICAN ART 54 East 68 Street New York, New York 10021

ACKNOWLEDGMENTS

The density of the material in this catalogue necessitated the collaboration of individuals whose vital contributions deserve acknowledgment. Special thanks go to Professor A.L. Starensier of Drew University for advice on the definition of ensembles, and to S.R. for her diligent and supportive editorial hand; Christian Duponcheel, James Ross Day, and Alfred Scheinberg for recommending and locating inaccessible reference matter; George Akyei, Nana Kyei Baffuor, II, Ariba Kyerima, and Captain A. E.O. Sam for assistance in the field; and to Ernst Anspach, and Mom for their continuous and timely support.

G.N.P.

We want to express our warmest thanks to many friends and colleagues who unhesitatingly helped us gather the works of art, the photographs, and the information that went into this exhibition and catalogue. We thank the following for their fine photographs: Lynton Gardiner, Jerry Thompson, Perkins Foss, Anita Glaze, David Binkley, Henry and Margaret Drewal, Daniel Biebuyck, Roy Sieber, and Carol MacCormack. Invaluable information and assistance were provided by Nancy I. Nooter; help in arranging loans was graciously given to us by Enid Schildkrout, Douglas Newton, Kate Ezra, Clara Gebauer, Eric Robertson, Michael Oliver, William Rubin, and Phyllis Hattis—we thank them all.

Assembling the elements for the catalogue was skillfully managed by Lynn Landy, Petty Benitez, Maria Epes, Elizabeth Gruson, Jean Wagner, Jeanne Mullin and S.R.—all of whom were a pleasure to work with. Finally we are most grateful to the lenders who speedily complied with our requests for photographs and information, and who generously parted with their precious works to make this exhibition possible.

S.V. & P.N.

Lenders

American Museum of Natural History, Department of Anthropology
Ernst Anspach
William Arnett
Herbert Baker, Palm Springs Desert Museum
Bardar Collection, Belmont, Massachusetts
Mr. and Mrs. William W. Brill
Dona Bronson
The Chang Trust
Gerald and Lila Dannenberg
Collection Delbanco
Geraldine and Morton Dimondstein
Drs. John and Nicole Dintenfass
Ernest and Jeri Drucker
Duponcheel Collection
Harrison Eiteljorg
Drs. Jean and Noble Endicott
Richard Faletti
Murray and Barbara Frum
Clara Gebauer, Walter Gebauer, and Anne Gebauer Hardy
Marc and Denyse Ginzberg
Anita J. Glaze
Hubert Goldet, Paris
Max Granick
Renee and Chaim Gross
Philippe Guimiot
Lawrence Gussman
Jay and Clayre Haft
Hammer Collection, Chicago
Karob Collection, Boston
Justin and Elisabeth Lang

Hélène and Philippe Leloup
Yulla Lipchitz
Dr. and Mrs. Robert Magoon
Drs. Daniel and Marian Malcolm
Junis and Burton Marcus
Genevieve McMillan
Menil Collection
Metropolitan Museum of Art
The University of Michigan Museum of Art
Robert and Nancy Nooter
The University Museum, University of Pennsylvania
Portland Art Museum
Philip Ravenhill and Judith Timyan
Dorothy Brill Robbins
Mrs. and Mrs. Harold Rome
Mr. and Mrs. John N. Rosekrans, Jr.
Frieda and Milton F. Rosenthal
Gustave and Franyo Schindler
Gerald and Leona Shapiro
M.W. Shapiro
Merton D. Simpson Gallery
Cecilia and Irwin Smiley
National Museum of Natural History, Smithsonian Institution
Mr. Allan Stone
Mr. and Mrs. Arnold Syrop
The May Weber Foundation, Chicago, Illinois
Faith-dorian and Martin Wright
William and Niki Wright
Mrs. Lester Wunderman
Yale University Art Gallery
and five anonymous lenders

CONTENTS

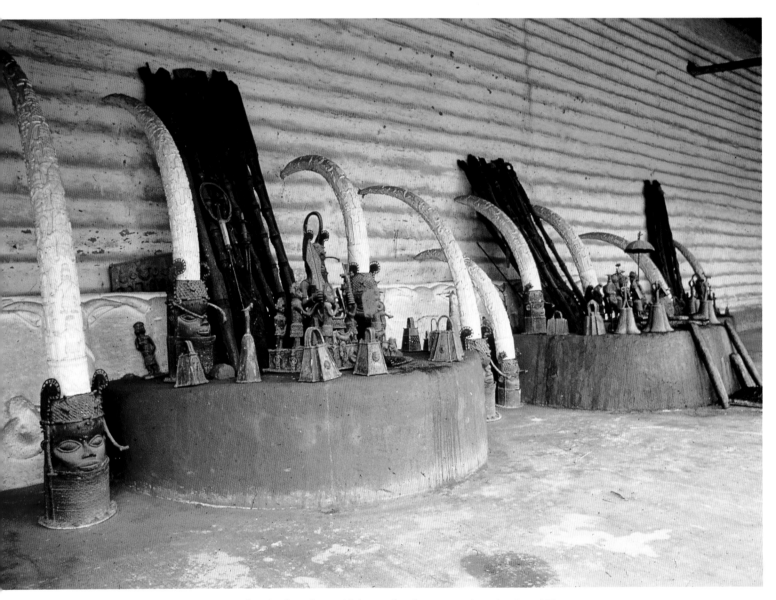

Fig. 1 *Nigeria, Benin City. Altar in the palace with bronze heads.* Photo: Eliot Elisofon 1970

Fig. 2–3 *Nigeria, Urhobo. Nature spirit shrine at Agbarho housing eleven figures.* Left: *second generation figures.*
Right: *first generation ca. 1875.* Photo: Perkins Foss 1971 *(overleaf)*

INTRODUCTION

Susan Vogel, *Executive Director*

THE CENTER FOR AFRICAN ART

The Center for African Art is proud to present a fundamental, but unexplored, aspect of African art in its third exhibition, "Sets, Series, and Ensembles," conceived by guest curator George Preston. African sculpture, like most art, was meant to be seen in the company of other works; in Europe, until easel painting became predominant, even the greatest paintings and sculptures were intended to be seen as part of palace or church decor, surrounded by related (if lesser) works.

African art is now frequently discussed in its context, but rarely is that context the artistic and aesthetic one of artistic programs or the relationship of one sculpture to another. Rather, the framework in which this art is most often presented is non-aesthetic, the social and ethical meanings that were part of the original experience of the works of art. The important relationships between sculpture and the other arts of music, dance, fiber, and painting have been dealt with more often and will not be treated here.

The exhibition illustrates only a small selection of the types of ensembles that can be found in African art—many others could have been included. We have chosen groups that are interesting aesthetically and that we could illustrate with most or all of their parts. The majority of the ensembles presented here are necessarily reconstructions, made up of objects that are correct as to type but that did not comprise the original set. In the essay that follows, George Preston situates African sets, series, and ensembles in their intellectual framework. The texts by Polly Nooter that accompany the illustrations discuss the aesthetic and anthropological implications of the ensembles.

The objects in this exhibition were meant to be seen in groups (such as shrine sculptures), to be performed in sequences (such as initiation masks), or to serve a single purpose as a group (such as divination equipment). Excluded are pairs of objects (couples in African art are so prevalent as to be nearly universal) and random accumulations of works—such as the hosts of similar masks that appear in many festivals. "Sets, Series, and Ensembles" is limited to those works that are requisite for a given cult or function, and that stand in some fixed relationship to one other. It is characteristic of Africa that

these groups of objects vary over short distances, and that often the same cults or masquerades will require slightly different elements in different places. Many sets of figure sculptures, for example, are for shrines where the central images of the deity and his or her spouse are surrounded by attendants and lesser figures that may be progressively added to the ensemble as the deity reveals its requirements to those who maintain the cult. In time, the sculptural group in a given shrine will increase or decline, reflecting the changing prosperity and size of the community of worshippers.

Certain sets and series are never seen together but form a conceptual or temporal group. In many parts of Africa, initiates in collective associations graduate to ever higher grades over a lifetime. Thus, in some societies, for example, every seven years a man might be introduced to a new type of mask associated with progressively higher initiation grades. All the masks used by such an initiation society constitute a series in the minds of their owners, even though the masks might never appear simultaneously. Other conceptual groups exist in African classification systems. Sculptured heads for ancestral altars are made in Benin for kings, chiefs, and members of the casters' guild. Those on royal altars are cast in bronze; those owned by the casters are modeled in clay; and those belonging to chiefs are carved in wood. Though they were never physically together, these three kinds of heads were understood in contrast to one another.

Considering African art in sets and series is revealing in a number of ways: first of all it shows us how some works actually looked in their original settings. Urhobo shrine figures (nos. 49–51) are suddenly different when we experience them as they were created to be seen, massed together in a small space. Out of context and compared to other African sculpture, they appear large, summarily carved or ill-finished. In the original, cramped shrine setting, they were huge, overwhelming, awesome, or intimidating, and the details of their carving and finish were unimportant. In fact, fussy details would have distracted the viewer and lessened the effect of the ensemble as an ensemble (figs. 2–3).

Sets and series also reveal something about the way

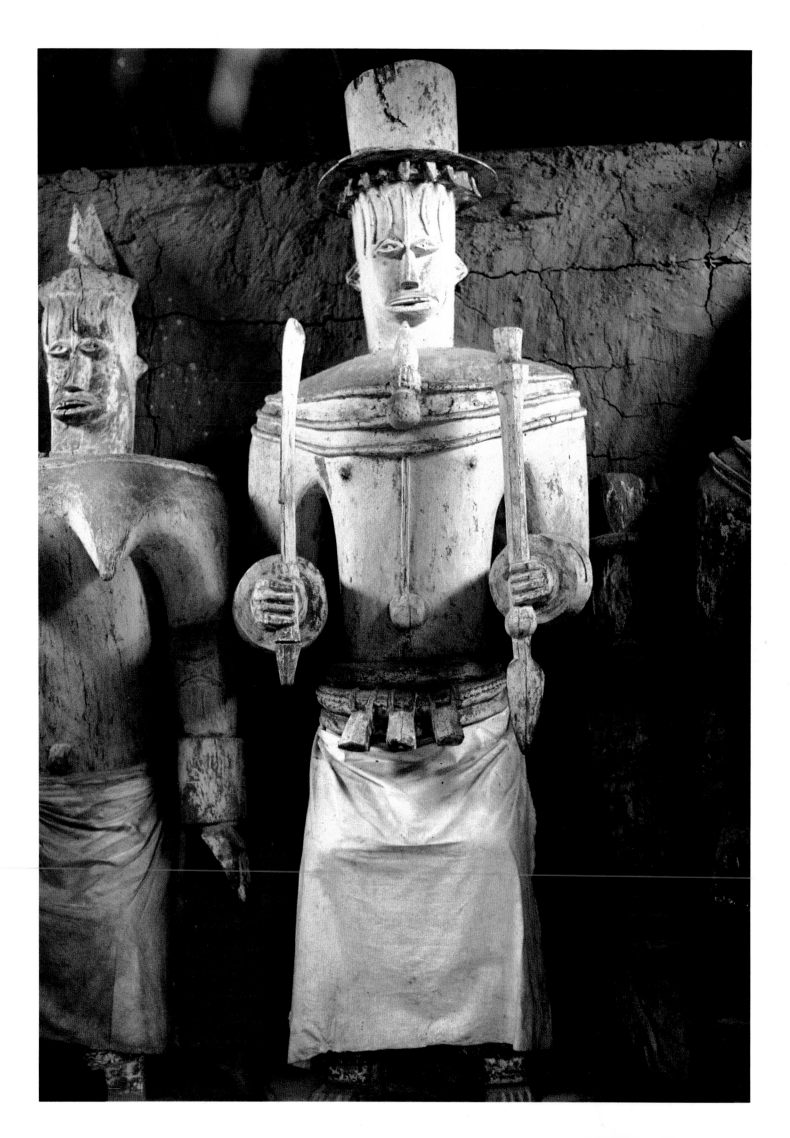

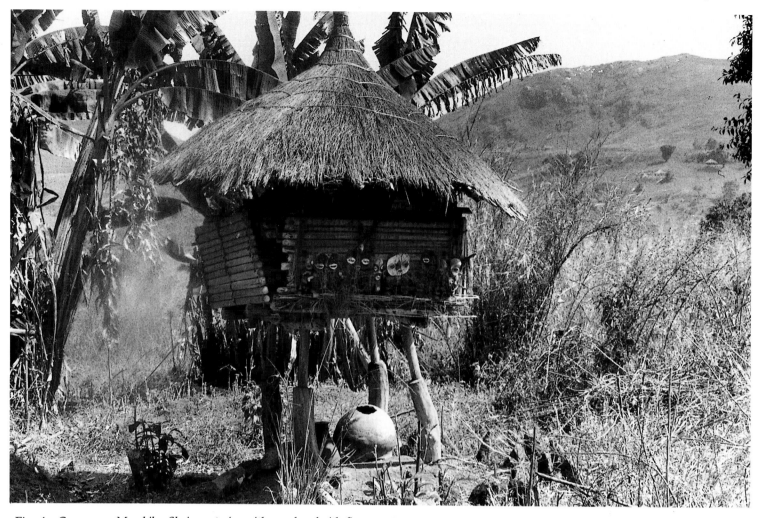

Fig. 4 *Cameroon, Mambila. Shrine exterior with wood and pith figures.* Photo: Paul Gebauer 1936

artists worked. Usually, sculptures in sets were made to join existing ones, providing the opportunity to see the influence of earlier styles upon those of succeeding generations. This exhibition presents the work of two generations of artists who made monumental figures for the Urhobo shrine at Agbarho. The older ones (fig. 3) are looming and voluminous, their limbs held in active, aggressive poses. Those of the second generation (fig. 2) are sharp-edged and linear, nervous, taller, and more erect than the earlier ones. Both sets express the militant spirit of the shrine, and both repeat the characteristic triple necklace, but in original ways.

Occasionally, an entire artistic program was executed over a short period of time, when a new ruler or cult was established or after the destruction of a palace or shrine. These large commissions afforded the artist a rare opportunity to work through certain formal problems and required him to continually vary the elements. In contrast, separate works executed by an artist for different clients are likely to resemble each other closely.

The graveposts on Malagasy tombs (fig. 10) were normally commissioned and executed in a short time and erected all at once. They either show an overall design, with certain themes (ie. figures of birds) repeated at intervals, or a succession of entirely different subjects.

Artists commissioned to carve sculptures for sets were expected to produce objects that were recognizable in terms of type or character, and that could not be mistaken for others of the same ensemble. Artists were admired if they included interesting and novel innovations. Bamana Djo figures (nos. 1–5) have never been seen or photographed in situ by a researcher, so that the exact composition of these groups is not known. The decontextualized figures, however, show a clear desire on the part of their makers to individualize each figure and to distinguish it from its mates. Few types of African sculpture display as wide a range of postures and gestures as these do. The three seated mother-with-child figures (nos. 1, 3, 4), for example, each show a different version of the traditional coiffure and hat, a different

12

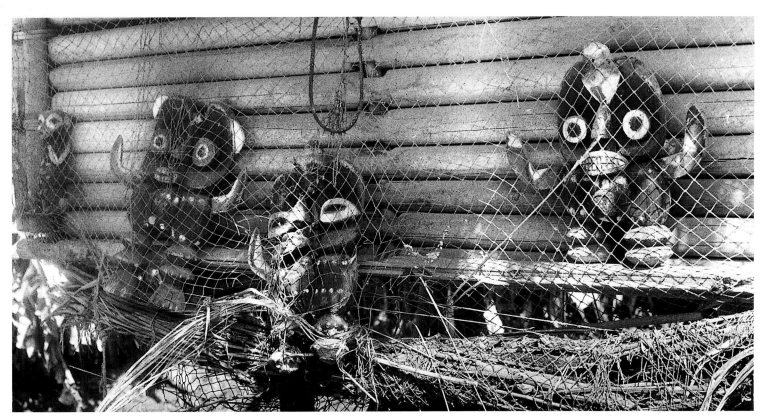

Fig. 5 *Cameroon, Mambila. Shrine exterior with pith figures.* Photo: Paul Gebauer 1936

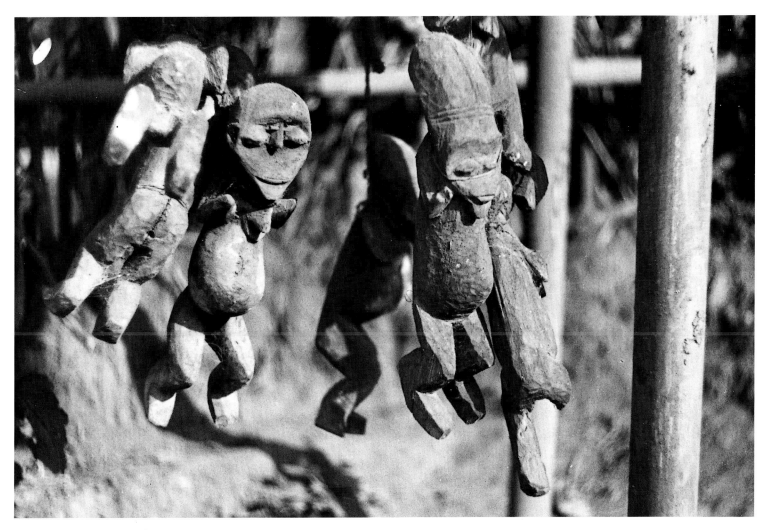

Fig. 6 *Cameroon, Mambila. Wood figures hanging from shrine.* Photo: Paul Gebauer 1936

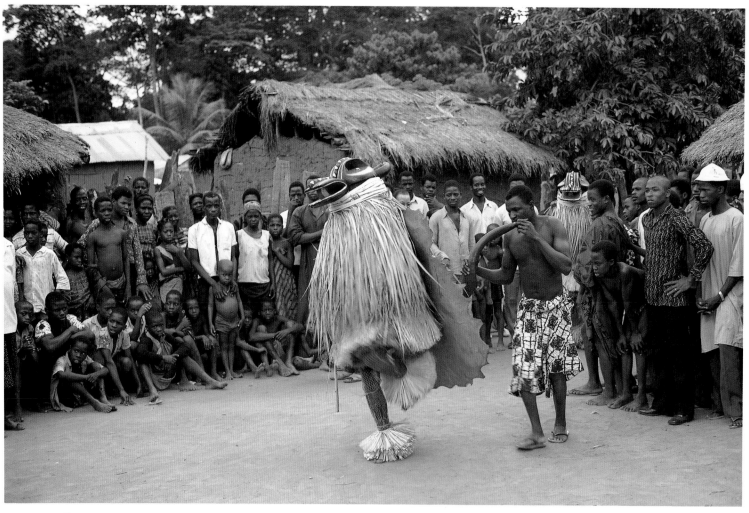

Fig. 7 *Ivory Coast, Baule. Goli dance with two senior male masks (Glin).* Photo: Susan Vogel 1971

Fig. 8 *Nigeria, Yoruba. Ifa diviner with board, bowl and tapper.* Photo: M. and H. Drewal 1982 *(opposite)*

style of seat, and numerous distinguishing emblems and ornaments.

Objects in groups provide insights into style that single works cannot. Some ensembles are composed of works so different in aspect that we would attribute them to different peoples, or to "archaic" and "later" periods, if we did not know otherwise. The four masks made by the Baule of the Ivory Coast for the Goli dance are a case in point. One (no. 25) is virtually flat, a plane on which are inscribed a few features; the next (no. 24) is a somewhat naturalistic human face with animal horns; the third is a fully sculptural horned helmet mask which combines the features of many animals with fantastic elements and uses stripes and areas of color to emphasize sculptural inventions; the last (no. 22) is a fully three-dimensional human face with carefully detailed coiffure and scarifications. In the Baule view, these masks describe a hierarchy of increasing importance

and idealization as reflected by their increasing three-dimensionality, naturalism, and complexity. The simplest mask is worn by a young, inexperienced dancer, the last is worn by a man of high prestige.

Other ensembles show a single style applied to a wide range of subjects and types of objects. The many different works of art created for Luba rulers all display the same rounded treatment of the body. The stools (nos. 75, 80), staffs (no. 77), and bowstand (no. 81), though entirely different in shape, nevertheless all use the soft, swelling volumes and crisp, faceted surface patterns that are typical of the Luba. Though some (such as the bowstand) are open in composition and others are closed, all treat the female figure similarly: particular emphasis is placed on the patterned torso and large head, especially the domed brow and heavy coiffure, and the limbs seem insignificant.

A single, dominating style in other ensembles can

14

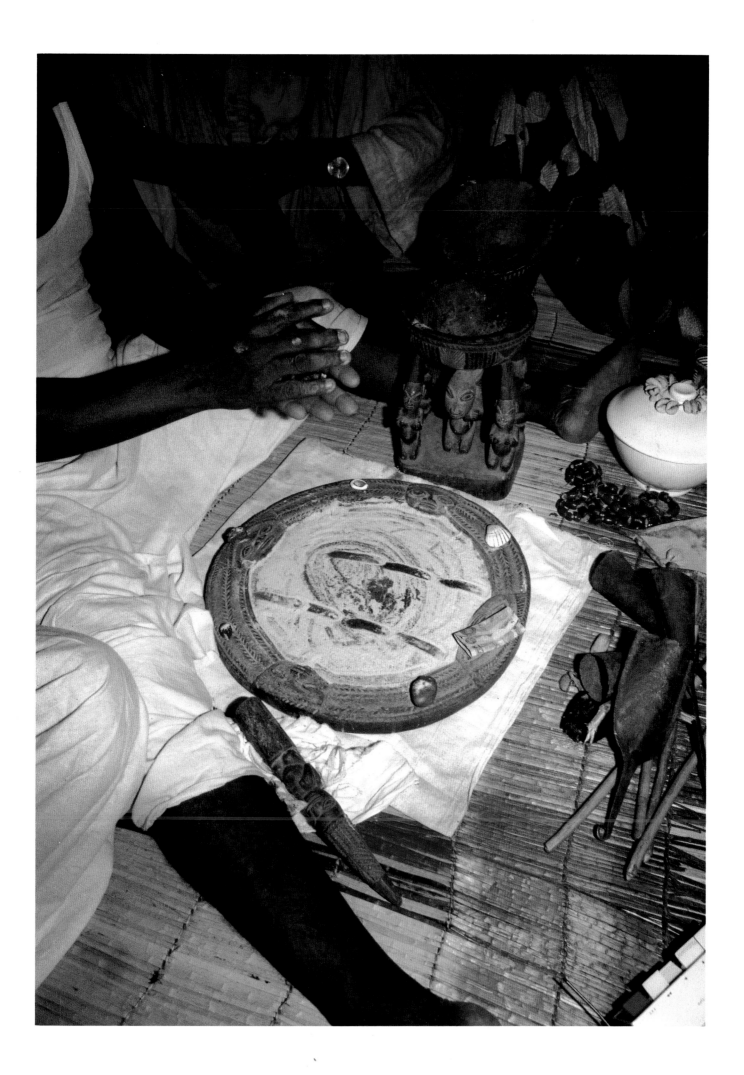

lead to a kind of tour-de-force reinvention of the human face or body. For example, the Lwalwa rigidly interpret the human face as a diamond bisected by slit eyes (nos. 71–72). In their mask ensembles, the subtle alteration of the shape of the nose—from wedge to block to hook— describes a change of character.

The exterior of Mambila shrine houses usually includes wood and pith figures (figs. 4–6) in front of a painting depicting other figures (no. 56), while inside is a pair of modeled terracotta figures (no. 57, 58). The carved and painted figures resemble one another closely, despite the different media: the rare surviving terracottas, however, seem to be more naturalistic in style. Whereas the painting and figures outside the shrine create an unstable, almost giddy, vision of the human figure, the terracottas inside are solidly planted, secure, immobile. These Mambila works are created in two somewhat different styles and seem to express conflicting visions.

Finally, sets and series are revealing when we survey the personae, characters, and subjects that recur in them. An overwhelming majority of shrine-figure groups, divination kits, and mask series reiterate what might be considered the great themes and preoccupations of African art: hierarchies that are based upon the family as a model. The figures that populate the shrines, tombs, and divination kits repeat the roles and types that make up the African world. Over and over, one sees depictions of ruler, elder, hunter, or warrior, accompanied by a young, fertile woman or a mother with child, for the family network with its principal human types constitutes a microcosm of the universe. Often, animals are included as mounts, sacrificial animals, or as symbols of wealth and prosperity. Sometimes, the dark side of existence is referred to, especially in the divination and initiation series where mourners, diseased persons, criminals, enemies, and outsiders are depicted. But, everywhere in sculptural groups, we see father, ruler, or defender surrounded by spouses, attendants, children. Sets and series mirror the ideal human community, depicting the hierarchies and the family structure that are the foundation of the African world.

SETS, SERIES & ENSEMBLES

George Nelson Preston, *Associate Professor of Art*

THE CITY COLLEGE OF NEW YORK

By the end of 1968 in the Ghanaian villages where I was doing research, I had firmly established the trust that gave me entree to rarely divulged information. Yet, I was unable to persuade the chiefs, elders, and custodians whom I had befriended to arrange for my photographing certain sculptures. Had I not gained their trust entirely? Was there something they wanted from me? Finally, several days before a major festival, they informed me that I would be able to photograph everything I had wanted. I eventually realized that they had found it impossible to imagine separating these objects from the ensembles to which they belonged merely to be photographed individually. They eventually comprehended the Euro-American classificatory approach with which I was studying their culture, and they gladly humored me.

Simultaneously, another revealing development took place. I was permitted entry to a shrine room in which were kept an ivory horn, an iron sword, a wooden stool, and a raffia basket filled with accretions of earth, sacrificial blood, seashells, and herbs covered with an imported silk cloth. The relief carving on the horn, sword, and stool had been obliterated by encrustations of sacrificial blood, wine, and gruel; the moisture of the blood had actually rusted away part of the sword.

In accordance with the system I had learned, I was regarding these objects solely in terms of the intrinsic values of their materials, in the hierarchical order of ivory, iron, wood, and raffia. Yet, I came to realize by then that the people who had made and revered the objects in the shrine room did not evaluate them according to a standard that measured ivory against rusty iron and that, furthermore, this was the most important ensemble of objects in their kingdom—of far greater significance than the elaborate, gold-covered pieces that were numerous and highly visible. The basket and its contents were not only made inaccessible by virtue of being confined to a shrine, but even in the shrine they were not easily visible.

I had arrived at yet another level of understanding that would lead to the present exhibition: in Africa, there is clearly an inverse relationship between the importance of an object and its visibility or accessibility; and the material it is made of is often less a clue to its importance as a spiritual force than is its relationship to objects in the ensemble to which it belongs.

Ensembles like those selected for this exhibition are made, used, and viewed as unitary programs, not as amalgams of separate objects. The individual components of each ensemble form in concert an integrated design that is the expression of an idea. Like most types of African art, an ensemble is commissioned by and dedicated to the service of some special person or society; and it is deployed, performed in, or associated with a specific site, a specific personage or office, or a specific, collectively held mental image or shrine.

The ensembles discussed in this essay and those displayed in this exhibition were selected on the basis of their beauty, the availability of their components, as well as for the way in which they represent different aspects of ensembles. Most express basic themes of African art: social hierarchy as an extension of social and cosmic order; the interrelated boundaries of ethos, cosmos, and hierarchy; the levels of godly revelation; and the accumulation of *mana*, or impersonal spiritual power. Juxtaposed within ensembles, the component objects together have the capacity to articulate or implement concepts by defining hierarchical systems, setting forth genealogical relationships, mapping cosmic order, revealing tacit verities not overtly acknowledged in daily life, legitimizing office, guiding transition between states of being, marking boundaries of ethos.

An ensemble's components, which have often been isolated from each other by the happenstance of collecting or by aesthetic considerations, are not fully legible by themselves, nor can their meaning be interpreted in context by identifying each of the parts. The translation requires a grammar as well as a dictionary. The elements of syntax to be considered in regarding the ensembles in this exhibition are: visibility and accessibility, the num-

ber of images associated with an idea or personage, relative position, mobility, sequence, locus or topography, duality.

* * *

Ensembles are an ideal vehicle for demonstrating social hierarchy and cosmic order and genealogy, because the members of an ensemble may appear over a period of time and in a sequence that is often determined by actual hierarchical order. Things of lesser importance usually precede those of greater importance, and things of greater visibility are not as important as those of lesser visibility. Examples of the relationship of visibility to importance are provided by the Toma peoples of southeastern Guinea and northeastern Sierra Leone. Great masks representing Afwi, the creator, are not as

visible as those of Afwi's lesser manifestations. All are part of an ensemble of masks and personages ranked in hierarchical order. Another example is provided by the Baule Goli masquerade, a celebration that expresses basic Baule distinctions between men and women, and village and bush. Three masks, representing personae junior and subordinate to Kpan—the senior female and symbol of the civilized village—appear well in advance of her as heralds. The lesser entities perform in high visibility over a long duration, but Kpan is seen more briefly, appearing late and dancing in measured steps, in view of the audience only for moments.

Ensembles also function to define physical and mental boundaries ritually. These performances may place people in hierarchical opposition to one another and pre-

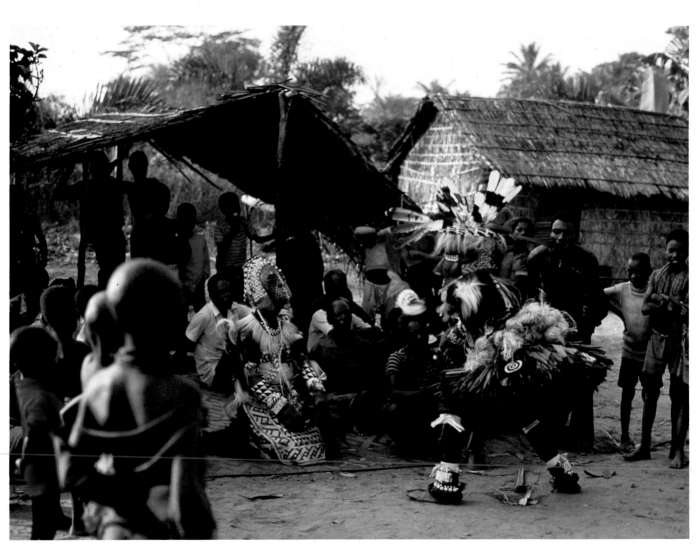

Fig. 9 *Zaire, Kuba. Performance at a funeral for a non-titled initiated man, Ngaady a Mwash mask resting while Mboom mask dances.* Photo: David A. Binkley 1982

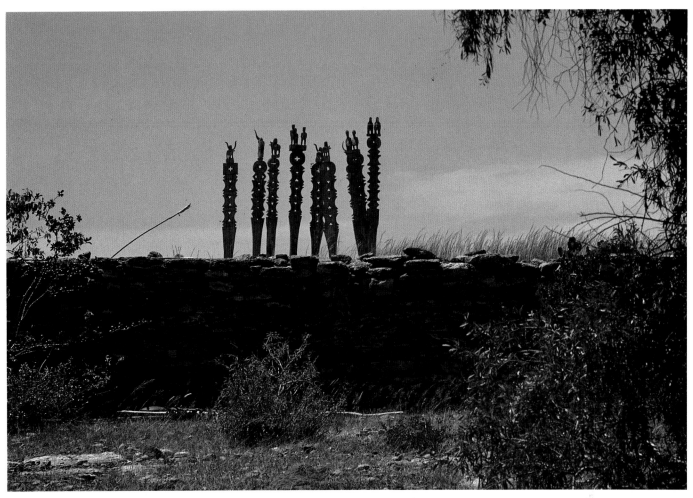

Fig. 10 *Madagascar, Mahafaly. Tomb with sculptured posts.* Photo: Susan Vogel 1979

scribe their movements according to their initiation status and sex. The actual barriers erected to define sacred and profane space or assigned areas of movement based on hierarchy are usually so physically flimsy that they function strictly as visual clues. Many ceremonies are rites of transition from one condition or status to another—unsocialized to socialized, commoners to royalty, village to forest, day to night—which, in turn, may require movement from one place to another. In many ceremonies, there is a movement back and forth between zones of perceived higher and lower status, indicating symbolically that the transition from a lower status is not easy. An example of shifting boundaries is the mock battle between lower and higher age sets in the Fokwe festival of the Atie of the southeastern Ivory Coast, in which the senior age group attempts to halt the advance of the younger one in a series of dramatized attacks and counterattacks.[1] Another example, from

southern Zaire, is the Bushong peoples' initiation in which the initiates make several series of forays away from and back to the village.[2] The effect can be likened to an accordion being worked in and out, with the initiate at the center of the bellows. The extreme positions represent some of the symbolically opposed locations and states of being cited above. Movements away from the center and back seem to increase progressively, signifying partial separation, until finally there is total separation and a new state of being.

Through sequence of presentation of an ensemble's components, masquerades provide the means to explain an earthly hierarchy as something ordained by higher powers. For the Akan peoples of Ghana, among others, society is an imitation of a stratified sacred order believed to exist between a supreme creator and its more approachable manifestations (lesser spirits and intermediaries). Earthly order may even be seen as an extension

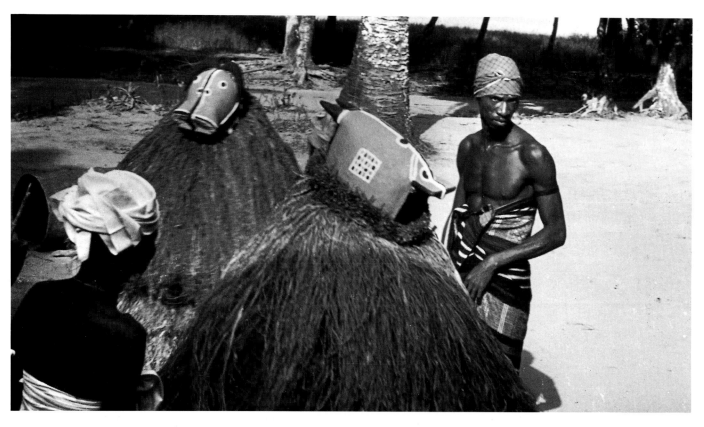

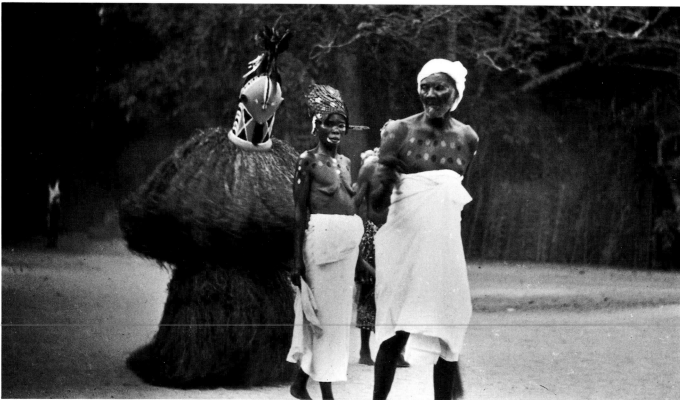

Fig. 11–12 *Sierra Leone, Sherbro. Initiation ritual. Top: first masks representing (L) hippopotamus and (R) antelope.*
Bottom: one of a pair of human masks with two living co-heads of the cult. Photo: Carol P. MacCormack 1970

20

of this perceived higher order. Many African leaders establish hierarchy as the dictate of God, the ancestors, or superhuman forces, thereby alligning themselves with the God-given order of the world. Indeed, it is the obligation of leadership to recognize this order and to give it perceptible form. The cinematographer Gaisseau's informant, the Toma priest Vwane, explained that God made human society as an extension of cosmic order. However, as for the masks, talismen, sculptures, and voice of the great spirit, he said, "We, the Zogi (priests) made all that...."[3]

In Africa, social and cosmic order and genealogical relationships are often seen as part of the same system. The pyramid of authority is surmounted by God at the top, followed by lesser spirits and earthly incarnations, males initiated into the forest or bush school,[4] and finally uninitiated humans at the bottom. Members occupying different rungs are perceived as relating to one another like the members of an extended family.

* * *

As with most types of African art, an ensemble is usually associated with one or more topographically separate but conceptually linked locations. A locus may be specific, such as the forest school and the main axis or plaza of a village. All forest and bush schools, sacred groves or forests, and circumcision camps, as they are alternately called, must be segregated from the town. Various boundaries such as grass walls or tunnellike raffia entrances signify the frontier between the world of spirits and the world of men.

An excellent example of the meaningful location is provided by masks under the patronage of the king of Bushong in southern Zaire. Bushong masks are composite, multilayered, representational, and symbolic entities embodying royal, ancestral, and forest forces. The palace is the terminus of a street that is the main axis of the capital. This street is divided by the central plaza. Behind the palace are housed foreigners and slaves. To its right is the royal quarter, while to its left is that of the commoners. That they are dressed at the palace and first appear on the street that divides the polity of the left (commoners) from the polity of the right (royalty), and that they proceed along this dividing line and then down the main axis to perform in the main square underscores the importance of locus in understanding the meaning of an ensemble (fig. 9). The use of these masks as implements of statecraft in the political mediation between royalty and commoners is indicated by the course of the masks down the street that literally divides left and right.

An obvious but little-explored dimension of locus is the person. In Africa, an accumulation of aesthetic objects is usually the prerogative of leadership.[5] Frequently, this accumulation of objects is found on the person of individuals or in their possession. We are not interested here in mere ornament, but rather in the regalia that identify rights, privileges, and prerogatives of offices of leadership, custodianship, or skill. Only regalia comprised of sets of components that function to establish the authority of office and to carry it out will be considered here. This focuses our discussion of regalia on those forms that represent the right to rule and without which the statecraft of art could not be practiced.

Regalia is not only worn on the person. Indeed, much regalia cannot be worn and is intended to be manipulated in lieu of the manipulation of people, replacing more overt and possibly less efficacious action.[6] A leader can extend his personal presence through the use of regalia. There are, for example, the numerous cases of the *noblesse oblige* of victor to vanquished wherein the victor confers forms of regalia associated with his hierarchy on the vanquished, who is thereby bound to accept an alliance more dignified than defeat. Historically, this has been practiced as state policy among the Bini, Akan, Bushongo, Luba, and numerous other expansionist peoples. Envoys of a ruler may be identified and given safe passage with a diplomatic passport in the form of a specific piece of regalia. If the regalia is recognized as belonging to the ensemble of objects that proclaims not merely the identity but also the prerogatives of the ruler, a *de facto* extension of his authority is achieved. Most importantly, since regalia is often believed to be charged with collective spiritual power, or *mana*, it serves as the implement by which the force of authority is exercised.

Another element of syntax to be considered is locus. Perhaps the most striking example of mental locus is provided by the sculpted heads of the Bini people of southern Nigeria (nos. 41–43). These were generic portraits that represented sacrificial victims, slain enemies of high status, and the predecessors of the Oba (the sacred king of the Bini). They were placed upon appropriately named "altars of the head" (fig. 1). Alloys of bronze and brass were the prerogative of the Oba, so that the heads owned by the subchiefs of various levels were wooden and those of the chiefs of the metalworkers' caste were terracotta.[7] The three media in which these heads were sculpted were ranked, in this instance, according to instrinsic value, with those in metal considered the most precious and therefore the most prestigious. Possession of the heads helped to define the

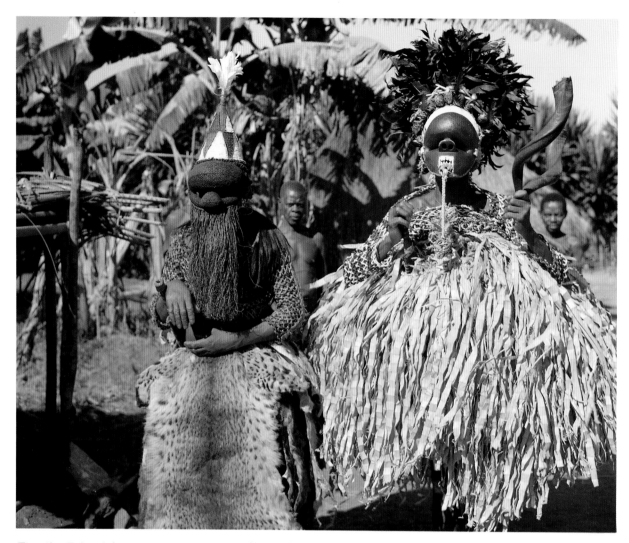

Fig. 13 *Zaire, Salampasu. Dancers wearing fiber and wood masks.* Photo: Michel Huet-Ag. Hoa-Qui 1960

levels of authority of the owner, and the existence of heads of different media formed a mental picture of comparative authority. While the three categories of heads were never physically together, they were conceived by the Bini people as a triad, or a set. When a Bini viewed one of these heads, he or she was aware of the existence of the others; the Bini's conceptual image of all the heads reinforced the hierarchical relationship between the Oba and his sub- and provincial chiefs.

A fundamental expression of the African ethos occurs consistently in African art including ensembles indicating male/female duality. For example, in the Thoma masquerade ceremonies of the Sherbro of Sierra Leone (figs. 11–12), this pairing is viewed hierarchically. First appears a pair of animal masks which not only represents animals as a lower order than humans but also makes metaphorical reference to the unsocialized nature of the uninitiated. Then follows a pair of human masks which symbolize the initiated status. A third pair in the sequence are Thoma elders who, because of their advanced age, must be interpreted as almost living

ancestors. MacCormack stated that in African thinking, human society is complete in the marriage between man and woman.[8] But, inherent in the completeness that results from the pairing of male and female is a paradox: human society is imperfect, for humans must mate in order to be whole. Sexless, formless, and pure spirit, the creator reveals the meaning of the male/female duality only to facilitate understanding on the part of mortals of their imperfection. Many ensembles of African art include invisible but audible expressions of the all-powerful deity, as, for example, when the voice of God, created by cult noise-makers and musical instruments, accompanies the pairs of masks described above when they travel between villages.[9] This same hierarchy—god, human, and animal—was observed by Gaisseau and his party at the entrance to a forest school of the Toma peoples of Guinea.[10]

* * *

Among the Toma (Loma) peoples of southeastern Guinea and northeastern Sierra Leone, a series of masked representations and personages reflects a hier-

archy of power wielded on earth by members of the Poro, a secret fraternity of senior initiates who possess the greatest cosmic knowledge in Toma society. An ensemble of masks under their control reveals the hierarchical levels of God's presence on earth. The constituents of the Toma cosmos are the creator, Afwi—the invisible, all-powerful, and unifying spiritual principle of a people who have no political unity—and the carnal or earthly representations of the creator. Great masks represent the creator's attributes and are accompanied by its voice, its ultimate manifestation, in the form of a group of musicians who play unique instruments in an occult musical language.

In northeastern Sierra Leone, these great masks called Dandai have a long, crocodillian mouth, hairy human nostrils, and penetrating eyes.[11] They are human in their intensity and animallike in their size. The massive forehead, baldness, and crown of eagle feathers announce the range of the creator's domain, intelligence, seniority, and omnipotence (no. 9). Fraser described this mask as "larger than life and superhuman in scale...."[12] In southeastern Guinea, where Afwi's mask is named after powerful ancestors, it combines the reptilian teeth and mouth with the curved horns of a ram, the tiny horns of a dwarf antelope (regarded as an elder inhabitant of the forest), the slit eyes associated with the female gender of smaller masks in the area, and a broad, curved mouth (no. 12). In both these types of masks, the forehead and facial planes of the face are divided into two distinct levels separated by superciliary arches which have been stylized into a prominent, straight ridge.

In southeastern Guinea, another mask type, known as Angbai, is a scaled-down, truncated, more rounded version of Dandai without the crocodilelike teeth. It was identified by earlier investigators such as Germann and Eberl-Elber as Dandai's consort.[13] The mask has the slit eyes typical of all female masks of the area. A variant of Angbai is horned.[14] A surrogate for Angbai seems to be Vollolibe, a female statue usually imbedded with fetish medicine. This statue is whirled in front of the mask of the creator at Poro meetings (no. 8). Gaisseau observed another example of this coupling: when members of the

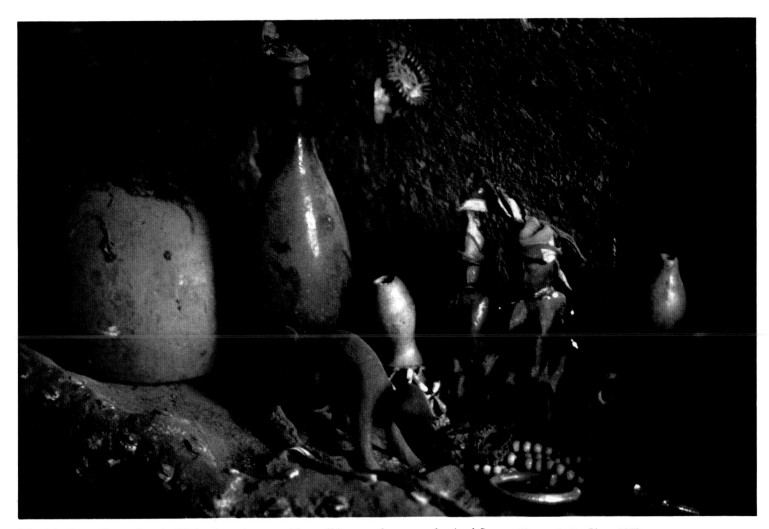

Fig. 14 *Ivory Coast, Senufo. Diviner's equipment with small bronzes, human and animal figures.* Photo: Anita Glaze 1973

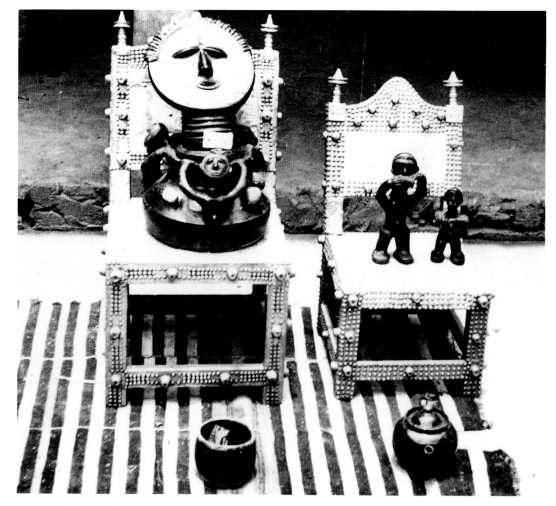

Fig. 15 *Ghana, Akan. (Kwahu). Funerary terracotta vessel with portrait lid made in 1962 and attendant figures on brass covered chairs.* Photo: Roy Sieber 1964

Poro convened in the sacred forest, the mask of the creator was present. It was laid upon the ground and, before sacrifices were poured on it, a miniature carving of Angbai was set upon its face.[15]

In opposition to Angbai's terrestrial character is her avian counterpart, costumed men called the Wenilegagi ("men of many birds"), who are proctors of the forest school (no. 10). Ranking below the bird men, who are believed to have descended from the time when men were giants and could fly, are the Gwelembe ("forest messengers"). The whitened, shaved heads of the latter masqueraders are visible above a collar, about three feet in diameter, from which hangs a long grass gown. Couriers between the forest school and the village, the "forest messengers" represent a state of transition between nature (forest) and culture (village). Ranking below these intermediaries are the candidates for initiation, not yet privy to the socializing education, tasks, and ordeals of the forest school which have been designed by the Poro elders to transform the proto-man into the Toma man.

* * *

For the Toma, earthly hierarchical order is an extension of cosmic order—a hierarchy presided over by Afwi and extended through its lesser manifestations all the way down to priests, adepts, initiates, and the uninitiated. For the Akan of Ghana, on the other hand, earthly hierarchies are based upon the genealogical relationships between Nyame (God) and its lesser spirits.[16] These are all seen as an extended family: priests perform appropriate rites dedicated to Nyame's lesser manifestations, family chiefs perform ceremonies for family groups, and the chiefs and other royalty preside over a cult of royal ancestors.

Until recently, it was the prerogative of members of Akan royalty to commission terracotta portraits and associated sculptures prior to their death. Constituting a sculptural *tableau vivant*, the portraits documented the role of the deceased in performing rites intended to maintain socio-religious order according to cosmic plan (fig. 15). The political and personal identities of royalty were dependent upon the description of an entourage of subalterns. Included in an Akan terracotta commemorative ensemble are paramount chiefs, subchiefs, and a

class of elders, each of whom had certain duties in his charge and was defined as "chief of the chamberlains," "chief of the treasury," "chief linguist."

The Akan use three modes of design to depict royal entourages. The first is the *abusua kuruwa* (lineage pot), a composite vessel whose lid is modeled in the form of a head or bust of the deceased. Heads, half figures, even full figures of members of the principal's entourage spring from the vessel's sloped walls, which are adorned as well with regalia and symbols identifying the personages. The second design mode consists of groups of individual figures arranged on the ground as if they were at the court of a chief, queen mother, or priest. A third mode was designed to illustrate the multiple roles of a chief as first among equals of the aristocracy, commander-in-chief of the army, chief magistrate, and custodian of the cult of royal ancestors. On certain holy days and at certain festivals, the chief changed his attire several times, in order to be appropriately dressed for these roles. Sometimes, a funerary ensemble consisted of more than one of these compositional modes, and sometimes the same personage was depicted in different apparel.

Among the Lwalwa of the Kasai region of southern Zaire, a dance called *ngongo* was performed by an ensemble of masks. The following interpretation is based on Paul Timmermans' description of the ceremony.[17] There are three pairs of masks: three male masks, called Mvondo, Shifola, and Nkaki (nos. 71–72), and one female mask, called Mushika. Apparently the three social levels represented in the male masks are 1) chief or chief-sculptor, 2) warriors and nobles, 3) able-bodied men and adolescent hunter adepts.

The behavior of the Lwalwa dancers and the emblematic horn and flywhisk that they carry in each hand enhance the explication of this hierarchy and comment upon the obligations of its members. This is dramatized in the deferential gestures the dancers make toward the notables, segregated from the audience of commoners, and the entertaining and threatening behavior they display alternately to the rest of the audience. The flywhisk represents culture, while the detached antelope horn—indicating man's domination of the forces of nature—is used here to threaten the onlookers. Thus, control of culture and nature is in the hands, both literally and figuratively, of the spirits represented by the masks, performed by *ngongo* under the patronage of the notables.

The fact that only one female mask is paired with three different male masks is a commentary on the status of women: they are appendages of chiefs, warriors,

or hunters. Nonetheless, it would be simplistic to define the role of women entirely on the basis of the ostensible dynamics of *ngongo*. The *ngongo* dancers are accompanied by a quartet performing on paired male and female drums and xylophones. The female drum is larger than the male drum; the female xylophone has ten keys and the male xylophone eight. The size and gender of the instruments are significant. It is clear from Timmerman's description that the musical instruments, played by men in a relentlessly driving style, energize the dancers and that the female instruments, being larger, provide the strongest voice.

The same female-male quartet is used by the neighboring Salampasu. The Salampasu produced several masks (fig. 13) whose decorative materials—pigment, parrot feathers, copper—as well as headdress and costume identified the rank and attributes of the wearer. The masks functioned at a men's initiation and circumcision (*chiki*) in the forest school,[18] at a funeral service for notables (*itshumbu*), at the women's initiation (*kabulukutu*), and at a rite of ablution (*mutumbu*) that protected the members of a secret fraternity of assassins (*akish*) from the souls of their victims as well as their survivors.[19] A masked *akish* was called *mukish*.[20] The highest-ranking *mukish* (*mu lunduwa*) was identified by large antelope horns he carried that were filled with organic charms and a large black mask topped by a bunch of parrot feathers. From fragmentary reports, one gleans that the most feared of the *mukish* was the *ukishi a mbata*, who assassinated his victims in forests and fields, and the *ukish a mayi*, who waylaid his prey at fording places.[21] These masks were painted in a red pigment (*tukula*) and a white pigment (*lupemba* or *pemba*) (no. 67). In the *mutumbo* rite, the assassin undergoing purification wore the mask dressed in a skirt of animal pelts.[22] At one phase of *mutumbo*, the ensemble of *mukish* danced on a platform, the base of which was decorated with high-relief carvings of a decapitated head and the body of a victim. *Mukish* appeared even at the female initiation, accompanied by unmasked female dancers.[23] The juxtaposition of mixed male and female dancers is similar to the pairing of hierarchically undifferentiated male and differentiated female masks of the Lwalwa, thereby demonstrating male dominance in Lwalwa and Salampean society.

In southern Zaire, a triad of Bushongo masks representing the culture hero Woot, his consort, Mweel, and the commoners, Mboom, is one of the most celebrated ensembles in African art. These masks work in concert with other masks and figures at Bushongo initiation

25

rites, forming an even larger ensemble. The triad also functions outside of initiation at funerals and at the installation of a chief, and forms the nucleus of the Bushongo masquerade. It is necessary to describe whom this triad represents, because the Bushongo use a single mask to embody more than one entity, as well as more than one mask to indicate a single entity. Through the use of three masks and their variants, several modes of thought—conceptual, political, and symbolic—are used to define social order. Woot is bringer of arts, crafts, political organization, and the male initiation rite. He is sometimes represented by a mask called Mwash a Mbooy (no. 63). Sometimes, this mask represents the king of the Bushongo, thereby underscoring his genealogical relationship with Woot. Another form, called Yool ("policeman"), is the highest mask on the initiation wall. This structure is one of the final barriers between the nearly socialized initiate and his return to the village as a socialized Bushongo.[24]

A primitive permutation of Woot is Minying, who first appears to the initiates walking backward, a naked man covered with pieces of raffia.[25] He sings epigrams of wisdom to the initiates, who are confined to the initiation shelter in the central plaza of the village. The initiates spend their first night sleeping on primitive palm-raffia mats.[26] They must approach certain phases of initiation by stepping backward—as does Minying—entering and leaving the initiation shed. Later, they are allowed to don the mask and to briefly "terrorize" the villagers. Perhaps, this symbolizes how initiation takes one from a lower to a higher state. In another permutation, the mask of Woot, then called Mwash a Mbooy, is worn by the king. Feigning anger, he thrusts his spear at the assembled crowd but is placated by the queen mother in an action that perhaps reflects her mediating influence.[27] At the male initiation, the mask appears as a leopard, "devouring" or ritually destroying the initiates' old status. This is accomplished symbolically through his being stationed at the mouth of the initiation tunnel, which the initiates enter by passing through his legs.

Mweel, Woot's sister, whom he married to produce the Bushongo peoples, is represented by the mask called Ngaady a Mwash (literally, "wife of Mwash a Mbooy [the mask]") (no. 64). When initiated boys are symbolically reborn by passing through her spread legs, Ngaady a Mwash is called Kalyengel, "mother of initiation". The role of consort she assumes here is not as Woot's wife but rather as his sister. Perhaps, this is the Bushongos' way of mitigating the incestuous nature of their relationship.[28]

The mask called Mboom is said to have originated with an indigenous, non-Bushongo people who were conquered. It represents an amalgam of the commoners, that is to say, the political left or those not recognized as belonging to the right (no. 65). This mask does not have the variety of names of the other members of the triad, suggesting the hierarchically static nature of servile status. At initiation, Mboom dances in competition with Mwash a Mbooy for the favors of Ngaady a Mwash, which probably symbolizes political lobbying and refers as well to the allure of the beautiful Mboom, despite its low status.

The variety of roles these masks play, their shifting locations, and their interrelatedness—all these factors allow Bushong elders to demonstrate both the fixed and flexible natures of hierarchical boundaries as well as the connections between cosmic and social order.

* * *

From the southern Sudan, extending in a southeasterly direction through northern Uganda, Ethiopia, the coast of Kenya, and across the Mozambique Channel on the Afro-Asian island of Madagascar, ensembles of monumental, commemorative statuary are found.[29] These sculptural sets were almost universally regarded on the mainland as a means of transferring the beneficence of individual ancestors, in the form of collective spiritual power, or *mana*, to the good of the commonweal. On Madagascar, this same end was accomplished through the sheer numbers and ostentation of the monuments.

These monuments are comprised of many elements, including large figures and tall, abstract posts, called tally poles, placed around a mound. An early account of the memorial shrines on the outskirts of a Bongo village in southern Sudan was provided in 1861 by the Welsh trader-explorer John Petherick.[30] According to Petherick, the sculptures "were said to represent the chief proceeding to a festival...followed by his retainers bearing viands and mau to the feast."[31] The botanist Georg Schweinfurth, who worked in the area between 1868 and 1871, described the statuary for a grave of a Bongo chief, with the image of the chief "followed in procession by his wives and children apparently issuing from the tomb."[32] We now know that at the end of one year after the death of a chief, a final festival was held by his survivors, during which the chief's portrait and the tally poles were inaugurated.[33] Various sources have identified these large figures as representing chiefs, great hunters, rainmakers, other principals, and their relatives.[34] The most significant component of these commemorative groups is the tally poles. These abstract

posts consist of tiers of concave and convex forms, each of which represent a specific animal killed by the deceased or by a relative. Sometimes, they assume a composite form, combining the post with the depiction of a human head (no. 98).[35]

The rituals associated with these monuments indicate that they were intended to transform the skill of a hunter in acquiring game into a collective force after his death. It was believed that this force could be harnessed most efficiently through the use of both the commemorative figures and the tally poles, or, in some instances, through a composite portrait-tally pole. The mound was regarded as the resting place of the soul of the deceased.[36] Supplication of a mound occurred when the help of a spirit manifestation of God was required for fishing and harpooning hippopotami. When a fishing or hunting party was about to start, roasted millet was scattered upon and around the ground. Evans-Pritchard described instances when a living hunter made a donation of his bounty so that a tally pole could be erected for a deceased relative.[37] Therefore, it seems that the kills of a great hunter could only be made available to communal use if put at an ancestor's disposal. According to the Kronenbergs, it is thought that the spirit of the bush is offended when hunters kill animals; they must appease the spirit by performing ritual death rites, especially after their first kill or the kill of a very large or fierce animal.[38] This ceremony requires the ritual piercing of the composite portrait-tally pole of a deceased hunter with an arrow which simultaneously kills the ancestral intermediary. In this way, death then becomes a purifying force and leads to rebirth. By making subsequent sacrifices to the dead hunter, the living assure themselves of the positive participation of their ancestors.

On Madagascar, there are strikingly similar grave monuments that date prior to the Merina conquests of the 1800s (fig. 10).[39] In those of the Betsileo peoples, bull imagery dominates; carved zebu horns serve as stylized tallies or have been implanted into platforms supported by memorial columns.[40] Like the coastal Kenyan monuments, the monuments of the Sakalava, Mahafaly (no. 97), and other groups on Madagascar have incised, similarly patterned surfaces. Finally, as in southern Sudan, depictions of water vessels of the deceased can be found atop some of the tally poles and on the vertical supports of Bara and Betsileo tombs.

Since World War II, the biographical data provided in animal-horn tallies and the depiction of slaves and fam-

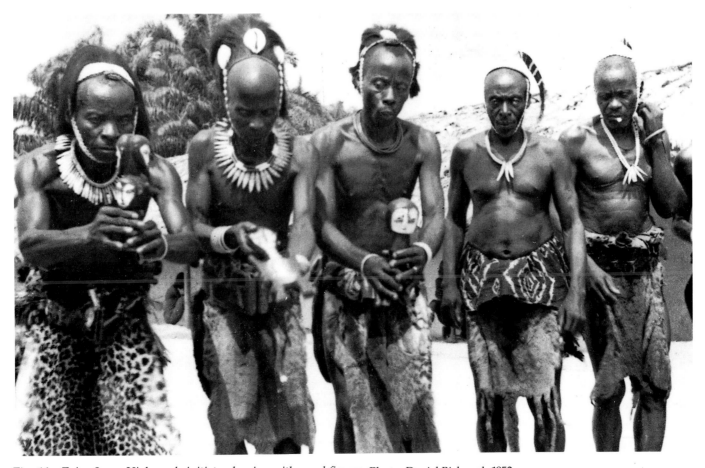

Fig. 16 *Zaire, Lega. High grade initiates dancing with wood figures.* Photo: Daniel Biebuyck 1952

ily members has changed to include the subject matter of a world in transition. In one shrine, the dead chief is depicted engaged in typical activities: sentencing a criminal, serving as counsel for village and family, being a successful hunter.[41] In an even more recent family tomb, reference is made to participating in a military unit, an airplane ride, owning cattle, receiving a military decoration, and sacrificing the horns of six zebu to the dead.[42] Significantly, these are family and not individual tombs, which encourages a cumulative, dense imagery, for collective achievement is obviously more visually impressive, and certainly more encyclopedic, than the biography of an individual.

<center>* * *</center>

The purpose of this exhibition and catalogue is to call attention to the importance of the ensemble in understanding African art. Mere groups or amalgams of sculpture whose components do not have specific sequential, positional, and iconographic relationships have not been included. Attention has been focused on sculptures that, in the past, have most frequently been separated from the sets, series, and programs to which they belonged or on those that lend themselves most readily to the thematic considerations discussed above.

While it has not been our aim to bring together the non-sculptural elements of an ensemble (for example, the Bongo memorial group is comprised of a mound with a tunnel, palisades, statues, tally poles, shelter roof, flags, animal bones and horns), field photographs have made it possible to describe these ensembles more completely.

The array of sculptures and objects that signal the status of the members of the Bwami, the initiation organization of the Lega peoples of eastern Zaire, poses a special problem, since it may be seen as an amalgam or as an ensemble (nos. 86–93). The five-tiered hierarchy of Bwami was not universal throughout Legaland, and, although the ivory and elephant-bone objects, particularly figures and spoons, were the property of the highest level, this most precious of materials was not confined to them.[43] The conspicuously large size of some wooden objects indicates their association with the most elevated group of Bwami members as well (fig. 16).

The didactic use of *Bwami* sculpture by the Lega appears to underscore the importance of ethics and morality for humankind in the constant challenge it faces to control the world.[44]

Like *Bwami* sculpture, the contents of the *ngombo ya cisuka* (no. 84), a divination set of sculptures of the Chokwe peoples of Angola and Zaire, represent a microcosm of the tribal world.[45] The diviner's manipulation of ideograms of the Chokwe cosmos in the form of sculptures and objects tossed in a basket emphasizes the role of chance in the affairs of humankind.

The fact that the Chokwe divination set, as with those of the Senufo and Yoruba, is used within a relatively confined spacial context is in contrast with the extended locus of Bwami sculpture. Yet, their not so disparate functions argue for the importance of studying African art in terms of syntax and theme. Examination of the Bushongo royal masquerade ensemble with this approach in mind reveals that it is not really a triad of masks but rather a triad of personages whose different roles require explication through the use of several masks. This is yet another example of the deepened awareness that the study of ensembles, as opposed to solitary objects, can provide.

NOTES

1. Monica Blackmun-Visona, "Fokwe: A Lagoon Age-Grade Festival as Performance Art," unpub. ms., delivered at the College Art Association, annual meeting, Los Angeles, 1985.

2. Jan Vansina, "Initiation Rituals of the Bushong," *Africa* 25, 2 (Apr. 1955), pp. 139–44.

3. Pierre Gaisseau, *The Sacred Forest* (New York, 1954), p. 229.

4. The forest school is so named because it is situated in the forest, away from towns and villages. It is variously called bush school, bush camp, circumcision school or camp, the latter name deriving from the fact that adolescents are circumcised at the site. The forest school is the secret place of initiation—a series of educational experiences and tests of will that transform a proto-citizen into a citizen. Included in the education are oral history and lore, musical traditions, expected

behavior, skills, and religious instruction. Some of the tests of will involve painful ordeals to form strong character, but they are now believed to be far less widespread than has been assumed.

5. An exception can be found among the Fante of Ghana, where the Pofohene ("chief of the seas and fishermen") is a high counselor of great authority who has no regalia and who, in fact, traditionally divests himself of all material wealth.

6. George Nelson Preston, "Dynamic/Static," in *African Art as Philosophy*, ed. D. Fraser (New York: 1974), p. 58.

7. Stacy Schaefer, "Benin Commemorative Heads," in *The Art of Power: The Power of Art*, eds. Paula Ben-Amos and Arnold Rubin, Exhibition catalog: Museum of Cultural History (Los Angeles: 1983), pp. 76–78.

8. Carol P. MacCormack, "Art and Symbolism in Thoma Ritual Among the Sherbro, Sierra Leone," *Ethnologische Zeitschrift Zuerich* 1980, no. 1 (1982), p. 155.

9. Ibid., p. 156.

10. Gaisseau (1954), p. 228.

11. Other names for the mask are Landa or Landau.

12. Douglas Fraser, "The Legendary Ancestor Tradition in West African Art," in *African Art as Philosophy*, ed. D. Fraser (New York, 1974), p. 40.

13. Paul Germann, *Die Völkerstamme im Norden von Liberia*, Leipzig, 1933, p. 121; Raolph Eberl-Elber, *Westafrikas letztes Rätzel: Erlebnisbericht über die Forschungsreise 1935 durch Sierra Leone* (Salzburg, 1936), fig. 196; idem, "Die Masken and Männerbünde in Sierra Leone," *Ethnos* 2 (1937), pp. 38–46. Gaisseau (1954), p. 37, however, had heard Angbai described as "man of many hides," probably because of the leopard, civet, hyena, and water-buffalo pelts it wore. Despite his encounter with this phrase, Angbai seems to represent the female sex. It is interesting to note, however, that the larger size often encountered in the female sex of paired statues or musical instruments does not exist here.

14. Germann (1933), pl. 9, fig. 2. Permutations of the Dandai/Angbai pair of masks are encountered as far east as the coast, where the Nalu make a polychromed version.

15. Gaisseau (1933), p. 107. Eugen Hildebrand, *Die Geheimbünde westafrikas als Problem der Religionswissenschaft*, Ph.D. thesis, University of Leipzig, 1937, pp. 134–36, reported that it was believed that Dandai devoured the initiates and then later regurgitated them. According to Gaisseau (1933), pls. 20, 21a-b, the X-shaped tatoo on the backs of graduates of the forest school was considered proof of their having been devoured by Dandai, for the tatoo was witness of the creator's teethmarks. Gaisseau informed this author (oral communication) that Poro priests could attain five tatoos and the masks six; only Afwi had seven. This further elaborates the levels of hierarchy in Afwi's cosmic order.

16. The Akan peoples include the Akim, Akuapim, Aowin, Asante, Fante, Twifo, etc.

17. Paul Timmermans, "Les Lwalwa," *Africa-Tervuren* 13, 3–4 (1967), p. 86–88.

18. Reverend Joe Henderson, *For the Congo and Christ* (New York: 1936), Chapters 10 and 12.

19. H. Bogaerts, "Bij de Basala Mpasu, de Koppensnellers van Kasai," *Zaire* 4, 4 (Apr. 1950), p. 394.

20. Henderson, letter of May 10, 1944, from the village of Kandembu, in author's files.

21. Bogaerts (1950), pp. 401–02; Henderson 1936, Chapter 10.

22. Bogaerts (1950), p. 394. In field photographs, these are the copper-laminated and woven masks (see Michel Huet, *The Dance, Art, and Ritual of Africa* [New York: 1978], pl. 236; François Neyt, *Traditional Arts and History of Zaire* [Brussels: 1981], fig. XI.6).

23. Bogaerts (1950), p. 394.

24. Vansina (1955), pp. 150–51, described the Bushong initiation wall as a penultimate phase of initiation. It is a metamorphosis of the three mounds inside the initiation tunnel, symbolic of the hills of Woot's primordial journey of enlightenment and of the founding of the Bushong dynasty.

25. Later, he reappears in the parure of Mwash a Mbooy.

26. The raffia of Minying's costume and of the mats the boys sleep on, as well as the segments of raffia stalks used for portions of Mwash a Mbooy's face, is symbolic of the intoxicating palm wine and the covering leaves of the first palm-wine tree in the myth of Woot's drunkenness, which led Woot to commit incest, which in turn led to the founding of the Bushongo royal line (see Huet [1978], pp. 193–94).

27. Joseph Cornet, *Art royal kuba* (Milan: 1982), p. 254.

28. There is also a mask called Ngat a Poong ("wife of the eagle"), another name for Mweel. Since eagle feathers are royal symbols, this nomenclature may provide a mate for Mweel when the incestuous relationship between her and Woot is referred to euphemistically instead of directly.

29. George Nelson Preston, *Style and Context of Monolithic and Monoxylic Monuments of Sudan, Ethiopia, Kenya*, unpub. ms., delivered at the Fifth Triennial Symposium on African Art, Atlanta, 1980.

30. John Petherick, *Egypt, the Soudan, and Central Africa* (Edinburgh, 1861).

31. Cited in Reverend J.G. Wood, "Africa," *The Natural History of Man* (London, 1874), vol. 1, p. 500.

32. Georg Schweinfurth, *The Heart of Africa* (London, 1873), p. 285.

33. Richard Wyndham, *The Gentle Savage: A Sudanese Journey in the Province of Bahr-el-Ghazal, Commonly Called "The Bog"* (London, 1936), p. 188.

34. E.E. Evans-Pritchard, "Megalithic Grave Monuments in the Anglo-Egyptian Sudan and Other Parts of East Africa," *Antiquity* 9 (1935), pp. 151–60; C.G. and Brenda Z. Seligman, *Pagan Tribes of the Nilotic Sudan* (London, 1932), pp. 470–71; A. and W. Kronenberg, "Die soziale Rolle der Jagd bei den Bongo," *Anthropos* 58, 3–4 (1963), pp. 508–509.

35. The earliest mention of these posts is that of T. Heughlin, *Reise in das Gebiet des Weissen Nil und seiner westlichen Zuflüsse in den Jahren 1862–1864*, (Leipzig: 1869). The Kronenbergs' photograph, taken in Bongoland about 1963 (pl. II), illustrates tally poles with depictions of human heads.

36. C.G. and Brenda Z. Seligman (1932), p. 205. The earliest form of mound was an assemblage of zebu horns, as well as the tether and stake used to hold the zebu sacrificed to the ancestor. These were inserted into the mound, which was shaped like the back of the bull. In some instances, horns or parts of carcasses of the sacrificed animals were implanted into the head of the portrait figure (see C.G. and Brenda Z. Seligman [1932], p. 473) or hung from posts planted in or near the tomb or shrine platform. Probably, these are what Petherick (1861, pp. 401–402) called "skull trees."

37. Cited in C.G. and Brenda Z. Seligman (1932), p. 473.

38. A. and W. Kronenberg (1932), p. 508.

39. Marcelle Urbain-Faublée, *L'Art malgache* (Paris, 1963), p. 17.

40. Ibid., figs. 29, 31.

41. Luis Marden and Albert Moldvay, "Madagascar: Island at the End of the World," *National Geographic* 132, 4 (Oct. 1967), ill. p. 443.

42. Ibid., ill. p. 470.

43. Nicolas de Kun, "L'Art lega," *Africa-Tervuren* 12, 3–4 (1966), p. 69.

44. Daniel P. Biebuyck, *Lega Culture: Art, Initiation, and Moral Philosophy Among a Central African People* (Berkeley: 1973), notes to pls. 31–33, 42.

45. Biebuyck (1973), notes to pls. 38–94; Marie-Louise Bastin, *La Sculpture Tshokwe*, (Meudon: 1982), pp. 55–57.

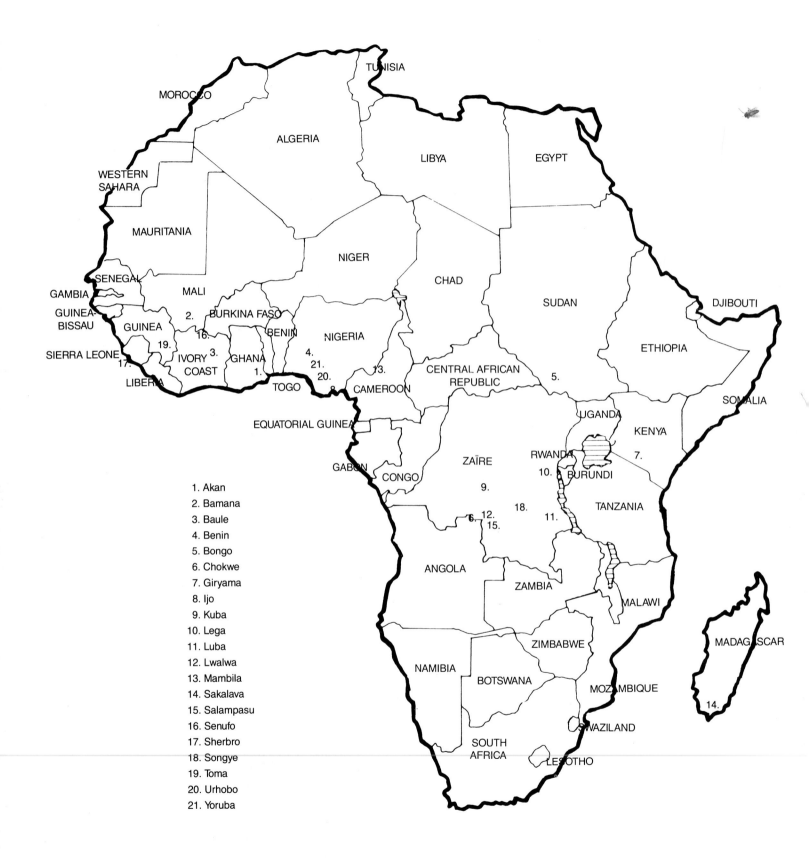

TUNISIA

MOROCCO

ALGERIA

LIBYA

EGYPT

WESTERN
SAHARA

MAURITANIA

NIGER

CHAD

SUDAN

DJIBOUTI

SENEGAL

MALI

GAMBIA

GUINEA-
BISSAU

GUINEA

2. BURKINA FASO

16.

BENIN

NIGERIA

ETHIOPIA

19.

3.

4.

CENTRAL AFRICAN
REPUBLIC

5.

SIERRA LEONE

17.

IVORY
COAST

GHANA

21.

SOMALIA

1.

20.

LIBERIA

TOGO

8.

CAMEROON

EQUATORIAL GUINEA

UGANDA

KENYA

GABON

CONGO

ZAÏRE

RWANDA

7.

10.

BURUNDI

9.

18.

TANZANIA

6. 12.

15.

11.

ANGOLA

ZAMBIA

MALAWI

MADAGASCAR

ZIMBABWE

NAMIBIA

BOTSWANA

MOZAMBIQUE

14.

SWAZILAND

SOUTH
AFRICA

LESOTHO

1. Akan
2. Bamana
3. Baule
4. Benin
5. Bongo
6. Chokwe
7. Giryama
8. Ijo
9. Kuba
10. Lega
11. Luba
12. Lwalwa
13. Mambila
14. Sakalava
15. Salampasu
16. Senufo
17. Sherbro
18. Songye
19. Toma
20. Urhobo
21. Yoruba

13.

1. *Mali, Bamana Mother and Child*
Wood H. 46½ in.
Collection Gustave and Franyo Schindler

Large male and female figures were used by
the Dyo society, a Bamana initiation association
devoted to the fertility of young women. These
figures are said to appear together in groups of
two to seven in shrine houses, though to date
no researcher has seen one in situ. In general,
these corpulent, softly rounded figures differ
from the rest of Bamana sculpture, which is
typically rectilinear, with flat planes and sharp
angles. The figures also depart from the nor-
mally static, timeless quality of African art with
their lively narrative and gestural poses. Most
significantly, the sculptures were meant to be
seen as an ensemble based on the human family
model, with a central male-female couple sur-
rounded by relatives and attendants. Mother-
and-child figures are the most frequent and
most functional of the group, since it was
believed that they actually helped infertile
women to conceive and to give birth to healthy,
beautiful children. *(Sources for nos. 1–5: Ezra in
Vogel 1981; Imperato 1983.)*

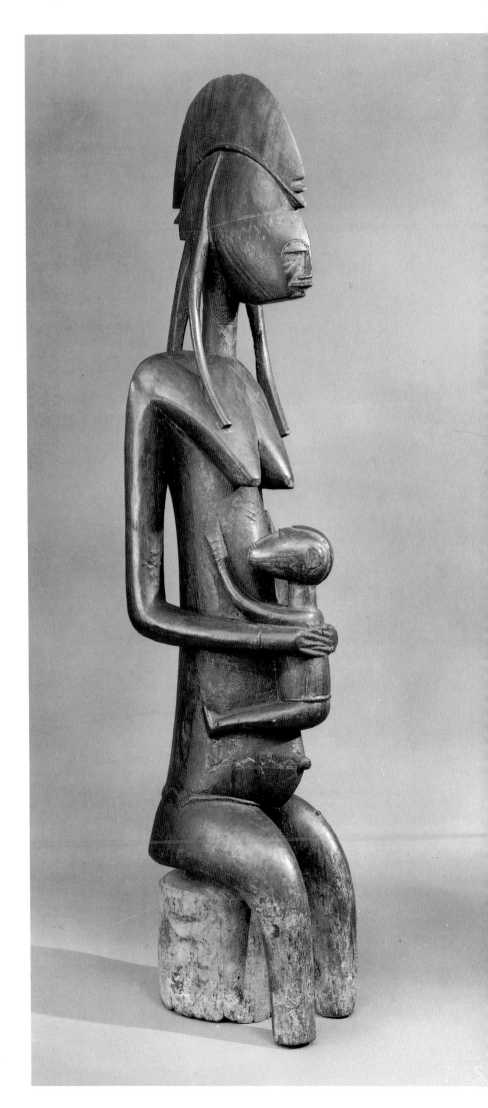

31

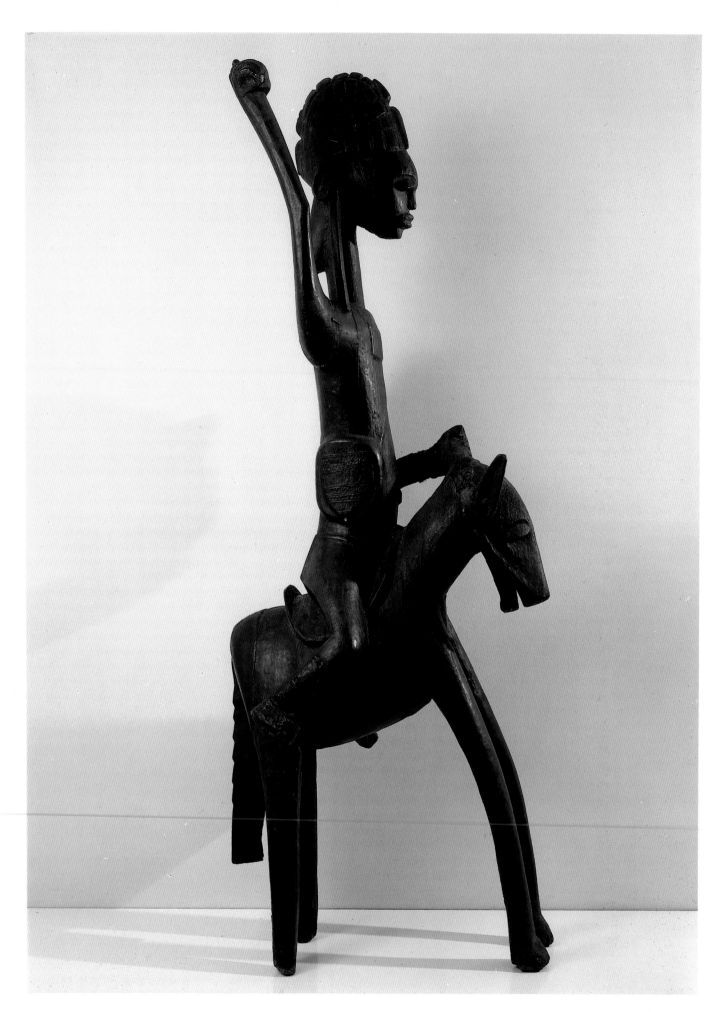

2. Mali, Bamana Male Equestrian Figure
Wood H. 52 in.
Private Collection

Male equestrian figures are frequently included in Bamana family shrine groups, for they embody the ethos of masculinity. The horse was introduced into Mali by Moslems and quickly became the symbol par excellence of male status: the owner of a horse was not only rich but also worldly, for horses were the best means of movement, long-distance communication, trade and warfare. The raised arm of this equestrian figure originally held a spear; the other rests on the rein. The subtle twist of the torso further offsets the symmetry of the piece, rendering it full of movement and surprise.

3. Mali, Bamana Mother and Child
Wood H. 45 in.
Private Collection

Despite the frequency of mother and child figures in Dyo society shrine groups, their formal variety is endless. Compared with the quiet attitude of No. 1, this figure seems remarkably active, with the child as a natural extension of the mother's gesturing arm. Women who are aided in conception by the Dyo society often name the child after one of the principal shrine figures, and offer a sacrifice on the doorstep of the house. Field studies have revealed different ideas about the subjects represented: one study identified the figures as mythical and historical personages, while Bamana people told another researcher that the female figures represent the various roles of women within the Dyo society.

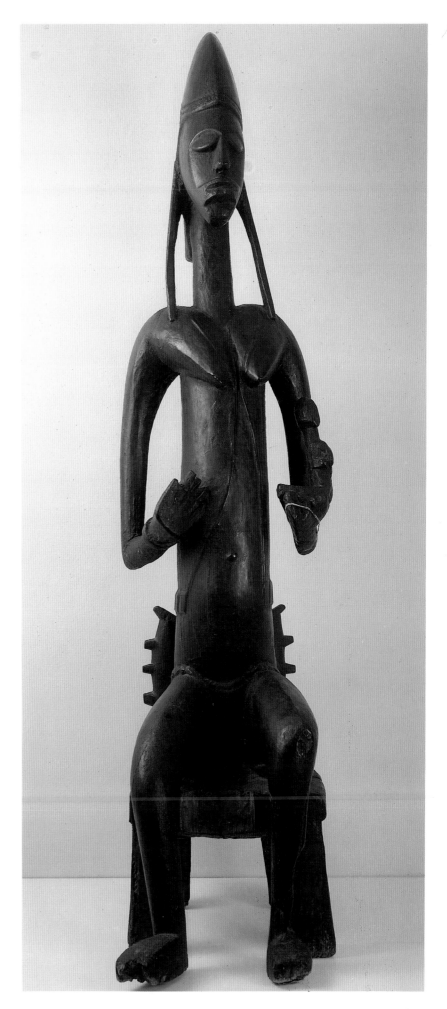

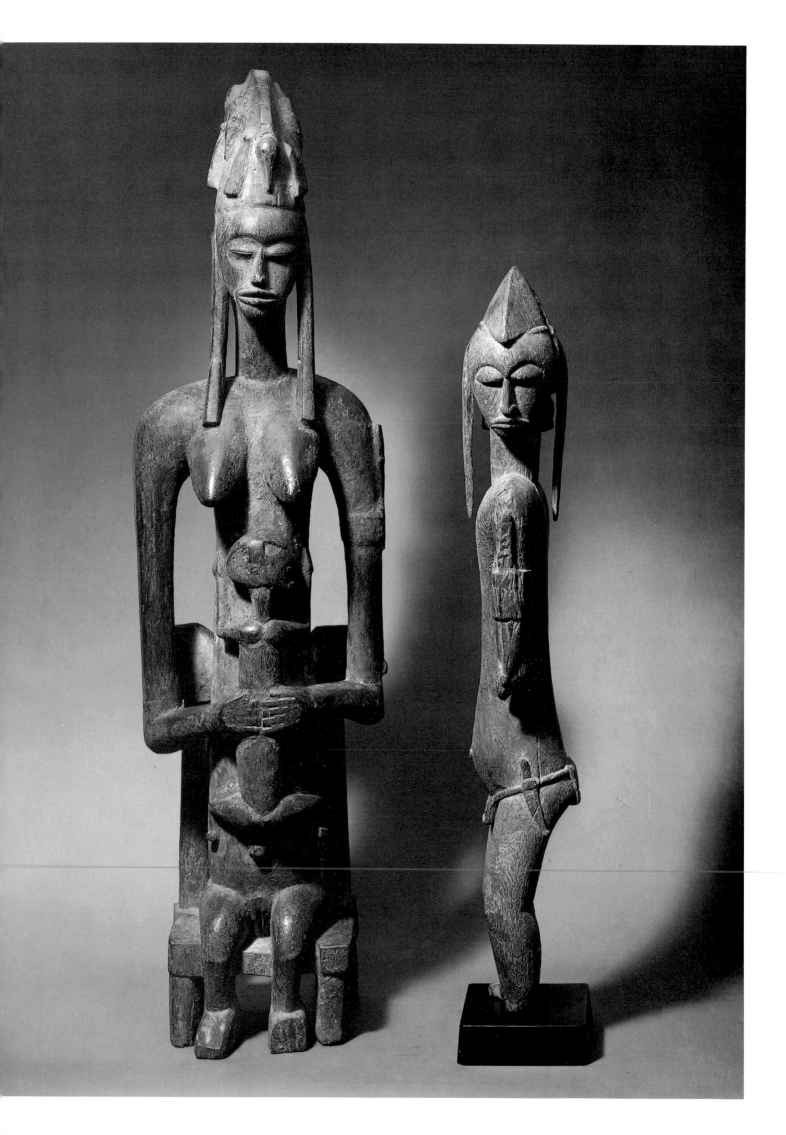

4. *Mali, Bamana Mother and Child*
Wood H. 43½ in.
Private Collection

As children are the centerpiece of Bamana life,
it is no surprise that the mother and child
theme predominates in Dyo Society figure
groups. Here, a small child clings to the elon-
gated torso of its mother who sits majestically
on an upright chair. Her coiffure, with long
braids falling gracefully around her shoulders,
has an unusual crest on which various sym-
bols—bows and arrows, tools and birds—are
carved in relief. The emphasis on the upper half
of the body, with the legs compressed to a frac-
tion of the composition, suggests the impor-
tance of the head and torso as the mental and
physical wellsprings of life.

5. *Mali, Bamana Standing Male Figure*
Wood H. 33½ in.
Private Collection

The dramatic turn of this figure's head is unu-
sual in African art, since it does not conform to
more typical canons of symmetry and balance.
The pose is found only in a few other African
cultures, including the Lobi of the Ivory Coast
and the Kongo and the Songye of Zaire. Its
meaning here is unknown, although it creates a
sense of alertness and readiness that is counter-
balanced by the composure of the face and
dignified stance of the body. In typical garb, this
male figure wears a knife in his belt and one on
his upper arm, signaling his role as hunter,
warrior, and protector of his family and commu-
nity. The relatively small size of this male figure,
in contrast to the female figures, is not uncom-
mon in African art, where women are fre-
quently portrayed as larger than men.

8. *Guinea or Sierra Leone, Toma Female Figure*
Wood H. 44 in.
Private Collection

Each of the masks worn in the series of Toma
initiation rites is formally related to the others by
elongated jaws and jutting brows. This female
figure which is also part of the series, intro-
duces an entirely different aesthetic. She is a
surrogate for one of the lesser masked spirits in
the hierarchy, but unlike the masks with their
composite human and animal forms, the figure
is a fully human woman wearing a necklace,
bracelets and a skirt. Its form may signify that
men and women, too, are extensions of the
deity's creations. (*Sources for nos. 8–12: Eberl-Elber
1936; Gaisseau 1954; Germann 1933.*)

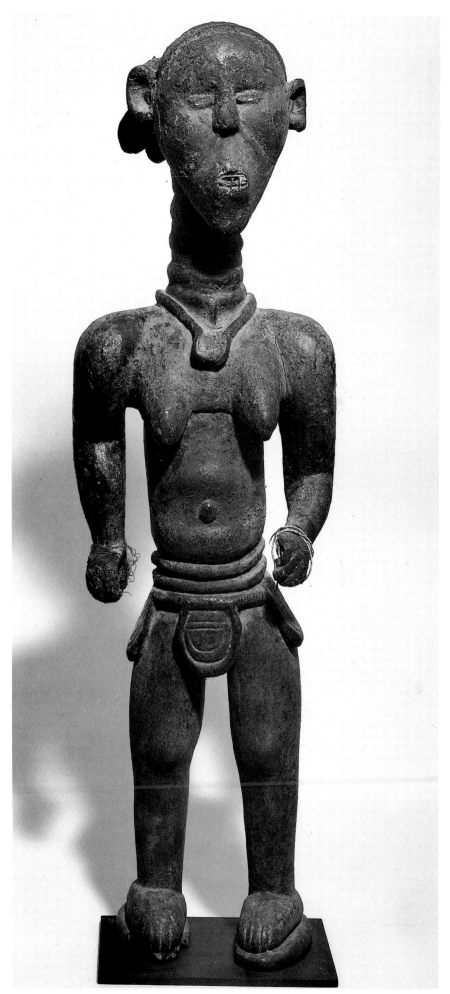

9. *Guinea or Sierra Leone, Toma*
Mask: Dandai
Wood, pigment, feathers, fiber, cloth, fur, hair,
skin, and aluminum
H. 65 in.
Harrison Eiteljorg Collection

The principal personage in Toma initiation rites
wears the largest of all masks, a crocodilian
creature with a thick crest of bird feathers and a
full raffia costume. These elements purposefully
merge the products of three environments: sky,
earth, and water. Since all masks that perform
in Toma initiation rites are extensions of the
creator deity, Afwi, it is fitting that the mask
should combine aspects of all his creation.

10. *Guinea or Sierra Leone, Toma*
Cloaks and Headdresses for Wenilegagi Dancers
Feathers, fabric
A. Cloak H. 44 in., Headdress H. 22 in.
B. Cloak H. 38 in., Headdress H. 26½ in.
Harrison Eiteljorg Collection

During initiation rites for Toma adolescents, the
forest school is proctored by costumed men
called Wenilegagi. These performers who incar-
nate the celestial realm don cloaks and head-
dresses made entirely of bird feathers. Called
"men of many birds," these costumed dancers
are a constant reminder to the young boys of the
many-faceted universe in which humans reside.

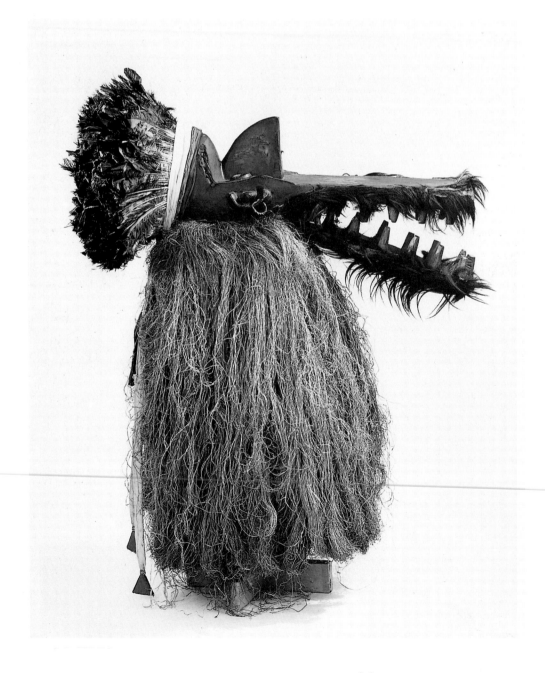

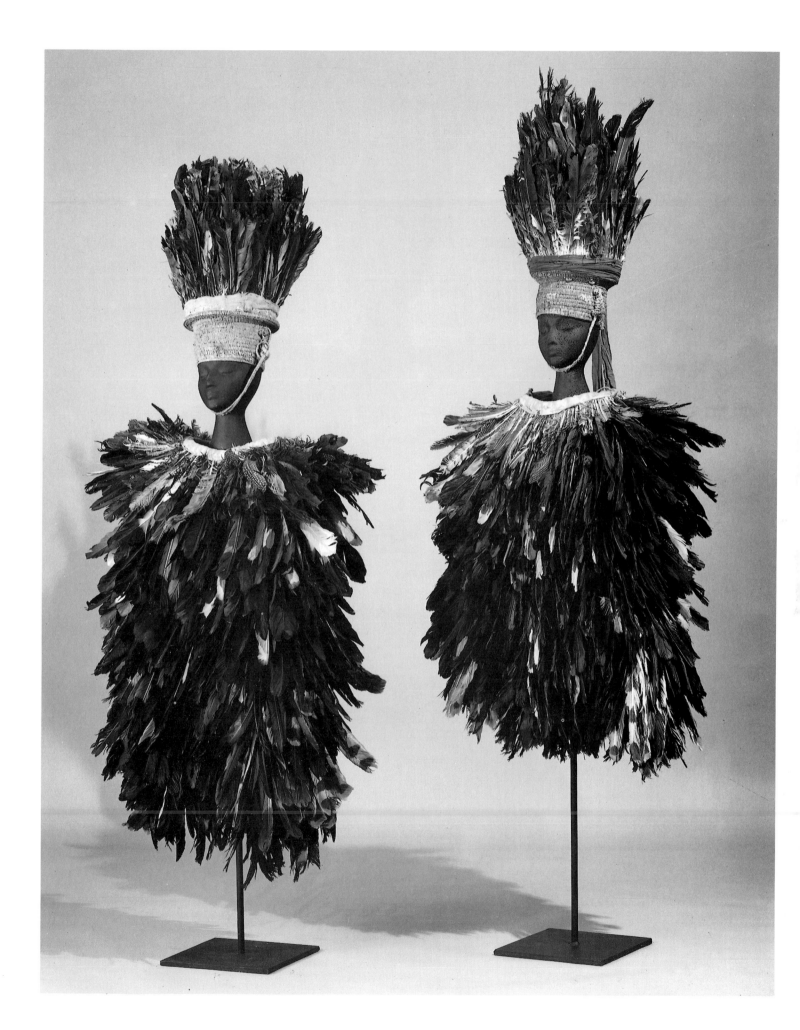

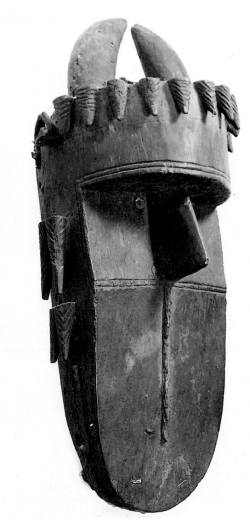

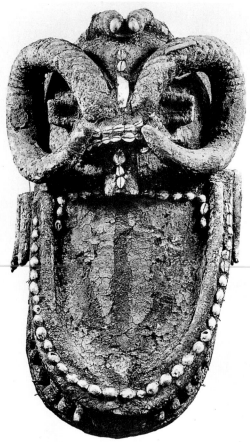

11. *Guinea or Sierra Leone, Toma*
Mask
Wood
H. 22 in.
Karob Collection, Boston

This mask is a lesser manifestation of the deity, Afwi, and a consort to the fiercest of the masks, Dandai. It shares many attributes of the latter—an elongated, flat face with overhanging brow, beady eyes, horns, and the division of the face into rectangular units—but on a diminished scale. With its eyes partially shadowed by the brow, this mask must have been an awesome sight for the young initiates when it emerged from the forest brandishing a whip.

12. *Guinea or Sierra Leone, Toma*
Mask
Wood, cowrie shells, horns, and other materials
H. 27 in.
Mr. and Mrs. William Brill Collection

African masks often combine animal and human features in composite forms that express the ambiguous boundaries between cultural and natural realms. Here, a human face mask is transformed into a zoomorph by the addition of curled horns. The attachment of cowrie shells around the outline of the face is a startling and coquettish contrast to the thick, crackled surface encrustation.

13. *Sierra Leone, Sherbro (?)*
Animal Mask
Wood, fiber, and other materials
H. 14 in.
Yale University Art Gallery Collection

The disheveled, tangled raffia wig encircling enormous staring eyes and bared teeth expresses the Sherbro notion of the uncivilized. This mask may have been one of a pair of animal masks that appeared before young initiates in a theatrical performance, conveying social roles and responsibilities. Like the Toma, the Sherbro evoke a sense of the untamed bush by actually incorporating its materials—wood, fiber, mud—into the mask. The result is a vibrant interplay of color, texture, volume, and line. (*Sources for nos. 13–16: MacCormack 1980, 1982.*)

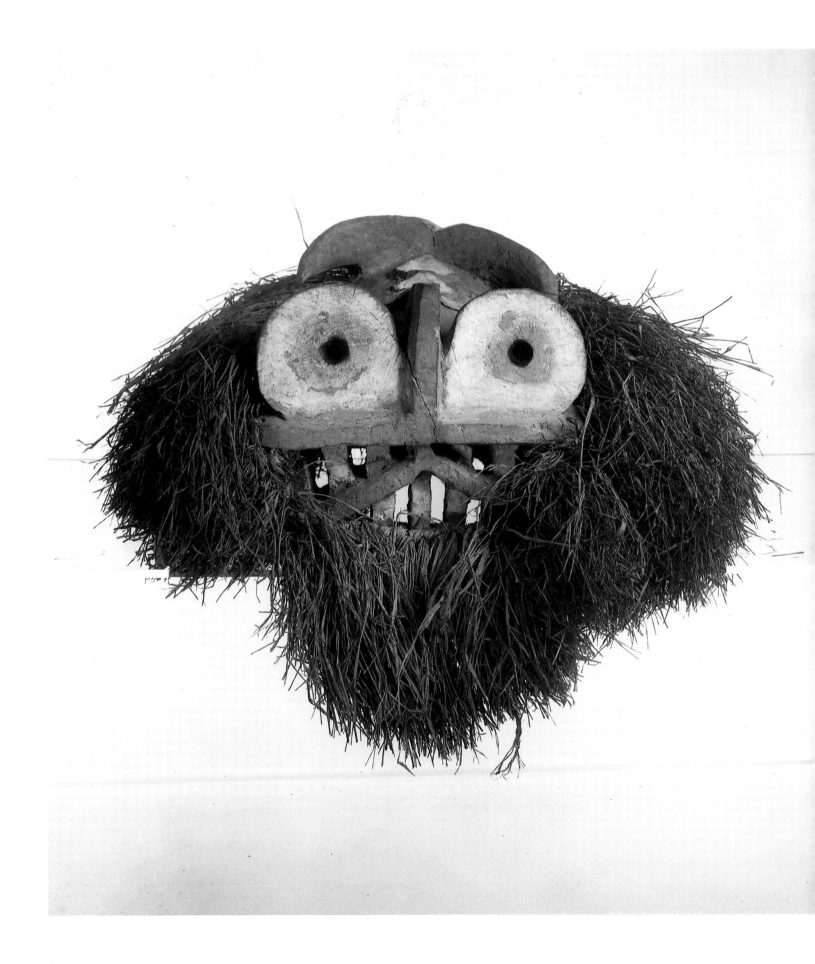

14. *Sierra Leone, Sherbro*
Animal Mask
Wood
H. 15 in.
Private Collection

The Sherbro view life as a passage from the uncultured, willful condition of childhood to the mature state of responsible and rule-bound adulthood. This passage is celebrated during the dry season, at which time masks perform in a particular sequence to express in symbolic terms the dichotomy between nature and culture. First in the sequence is a massive and powerful horned mask, such as this one, representing a land animal. It would emerge with another mask depicting a water animal to evoke the duality of the two realms, their contrasting qualities, their interrelatedness. The performance of these zoomorphs is a metaphor for unenlightened childhood and is followed by male and female anthropomorphic masks dramatizing aspects of adulthood. (*See fig. 11.*)

15. *Sierra Leone, Sherbro*
Mask
Wood, pigment
H. 13 in.
The May Weber Foundation Collection Chicago

A series of helmet masks is used by the principal Sherbro initiation society to teach ancestral laws and secret knowledge. These masks, with bold aggressive forms painted in red, white, and black, are worn with full raffia capes that fall in two tiers to the ground. Like most Sherbro masks, this one once had feathers attached to the top. Since birds navigate the air, and since the masked spirits are said to come to land from the watery underworld, the mask is a link between the three realms of life. (*See fig. 12.*)

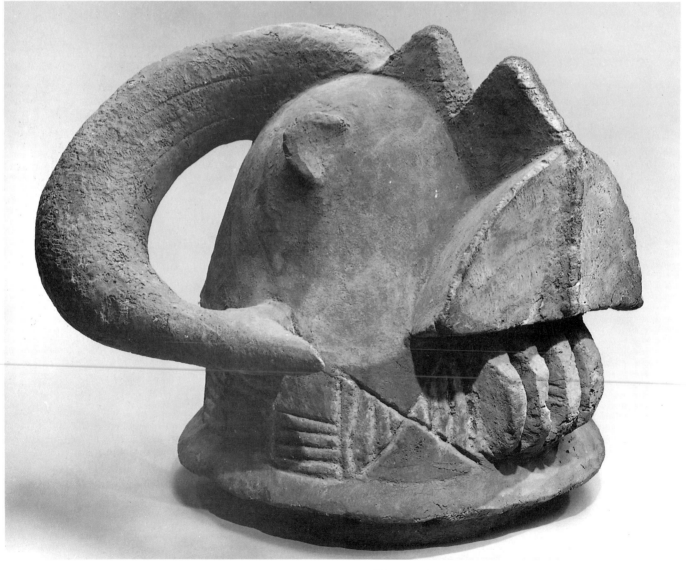

40

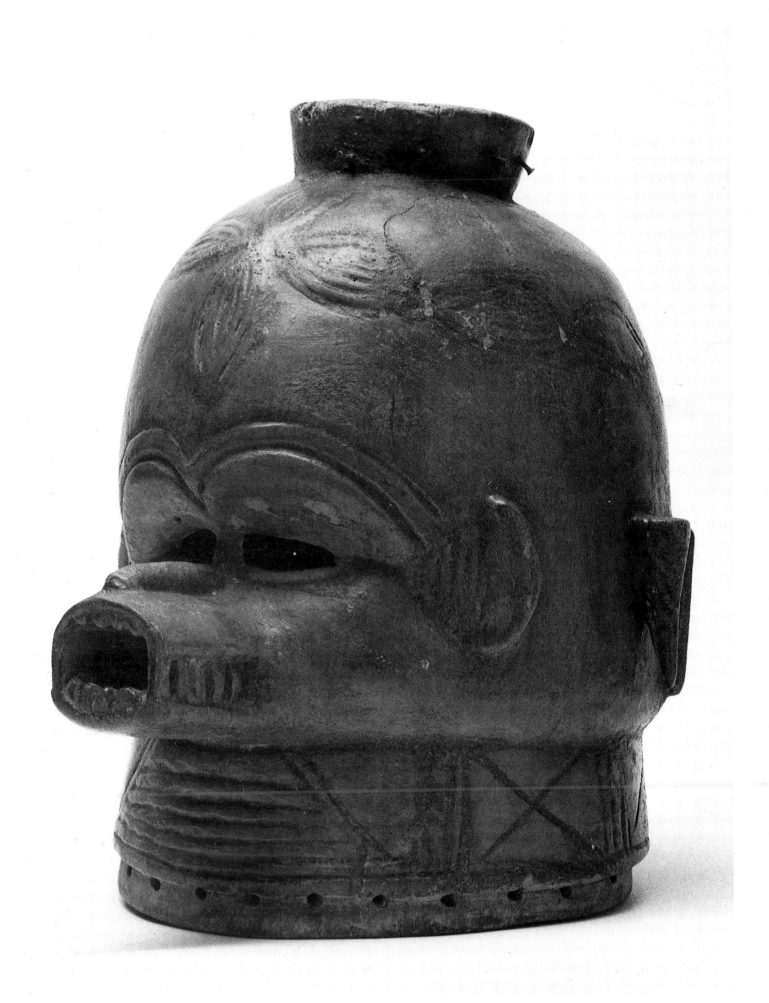

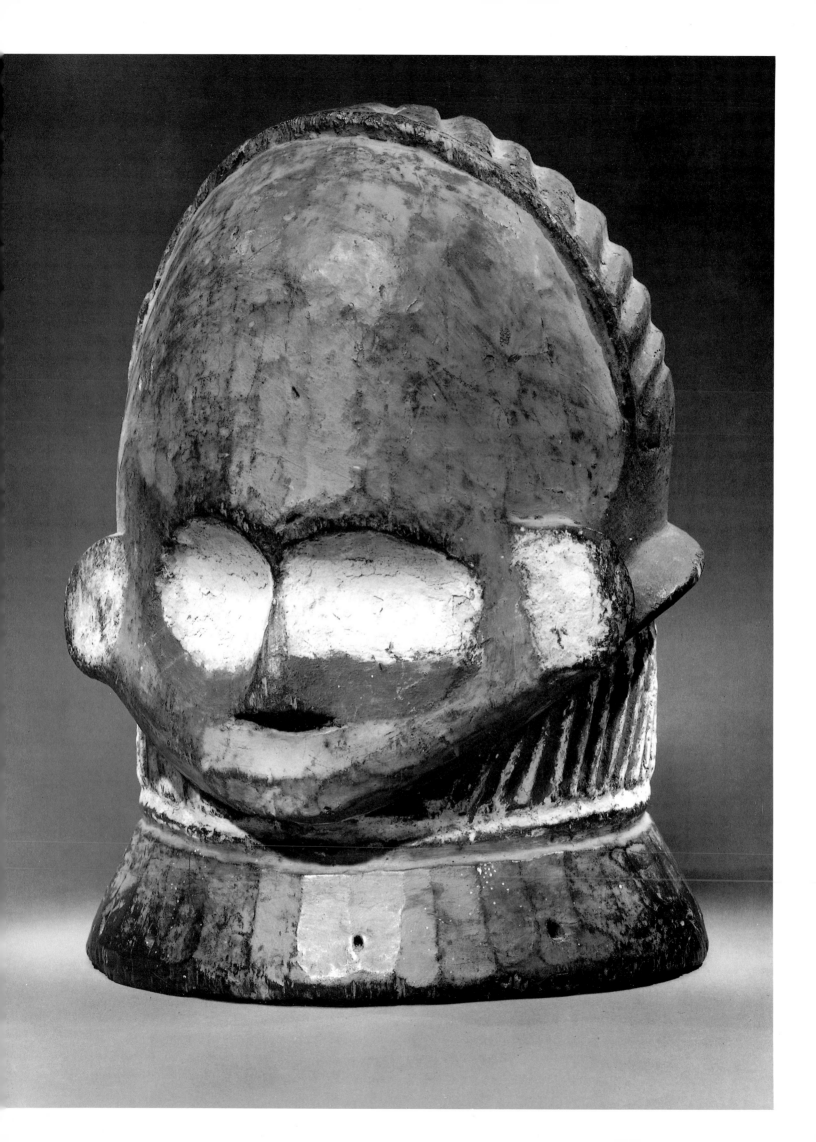

16. *Sierra Leone, Sherbro*
Female Mask
Wood, pigment
H. 13 in.
Faith-dorian and Martin Wright Collection

After the Sherbro dance arena has been
"warmed up" by the wild animal spirit masks
(no. 13, 14, 15), young initiates eagerly await the
next pair of masks, a male-female human pair.
In contrast to the untamed and chaotic nature
of the zoomorphs, the anthropomorphs are
refined, cultivated spirits who portray the ideal
man and woman, indicating their separate roles
in society and their interdependence in mar-
riage. This red mask has the whitened eyes and
neck rings of a young, healthy woman of child-
bearing age. Red signifies vitality and strength;
white is the blessing of the ancestors. For the
new initiates, returning home after their long
isolation in the bush, this masked performance
reinforces Sherbro philosophy, ethics, and the
division of labor.

22. *Ivory Coast, Baule*
Goli Mask: Kpan
Wood, paint
H. 18¼ in.
Hubert Goldet Collection

The four Goli masks, usually performing in
pairs (eight in all), represent junior and senior
personae, male and female, that form a hierar-
chy based on the family. This mask is the senior
female, and appears as the culmination of the
entire Goli series. Its movements and the
accompanying music are a marvel of grace and
harmony; its face shows both the perfection of
youth and the achievements of age. A leopard
skin on the dancer's back and fly whisks in his
hands complete the image of highest status.
Kpan is an idealization of feminine beauty and
power, and appearing in the place of honor in
the sequence, affirms the supreme spiritual
powers of women. (*Source for nos. 22–25: Vogel
1977.*)

24. *Ivory Coast, Baule*
Goli Mask: Kpan Pre
Wood
H. 13½ in.
Mr. and Mrs. Harold Rome Collection

Kpan Pre, the junior female of the Goli group, dances in second place. In style, this and the senior female mask (no. 22) resemble Baule figure sculpture, while the two male masks (no. 25, and fig. 7) do not. The Baule acquired the Goli mask dance with its alien, planar, and geometricized forms from the Wan about 1910. Lacking analogous forms in their own art, the Baule have stayed close to the Wan model for these masks while they have modified the more naturalistic masks to resemble their pre-existing sculpture style.

25. *Ivory Coast, Baule*
Gole Mask: Kouassi Gbe
Wood, paint
H. 13½ in.
Mr. and Mrs. Harold Rome Collection

The first dancers in the Goli ensemble wear this type of mask with a goat skin on their backs to represent the junior male, the lowest persona in the hierarchy. Sometimes identified as a servant, sometimes as a child of the senior masks, these masks are often worn by young, inexperienced dancers. The masks of such a pair, one painted red, the other black, (fig. 7) dance in alternation in a veiled competition of dancing skill. The extreme simplicity of this style and the relative absence of rounded volumes is exceptional in Baule art, probably because it is northern in origin.

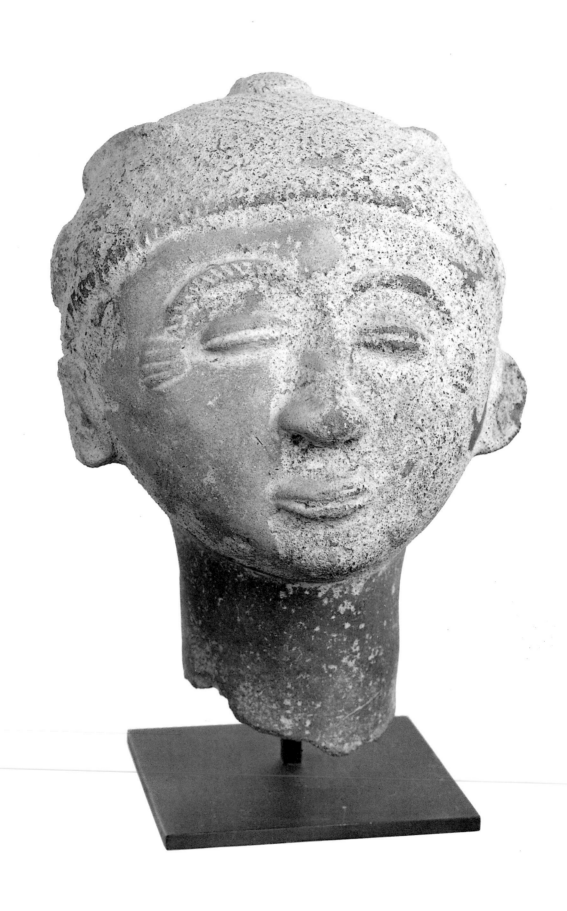

26. *Ghana, Akan*
Commemorative Head
Terracotta
H. 9 in.
Maurice Shapiro Collection

Portraiture is rare in Africa, where art frequently represents generalized beings and timeless concepts. Akan figurative terracottas, however, are true portraits of descendants of the royal matrilineal line. This sculpture would have been part of an ensemble of heads, busts, and full figures representing relatives and attendants placed in a sacred grove to commemorate the deceased and those who accompanied him or her in life. (*Source for nos. 26–28: Preston 1974.*)

27. *Ghana, Akan*
Funerary Food Bowl
Terracotta
H. 10½ in.
Genevieve McMillan Collection

In addition to figurative sculpture, Akan commemorative ensembles often include vessels, oil lamps, and food bowls with offerings to the dead. This food bowl is surmounted by a rooster, cacao pod, chamelion, tortoise, and snail, elevated on ringed columnar supports. Together with the figure sculptures, this bowl was a visual record of rites performed during the deceased's lifetime and promised a safe passage into the next world.

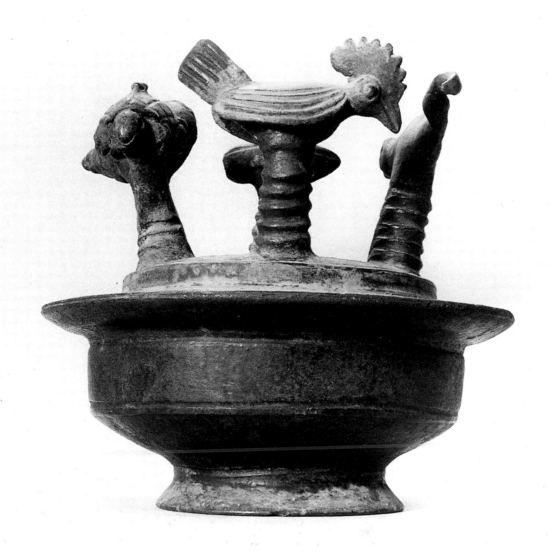

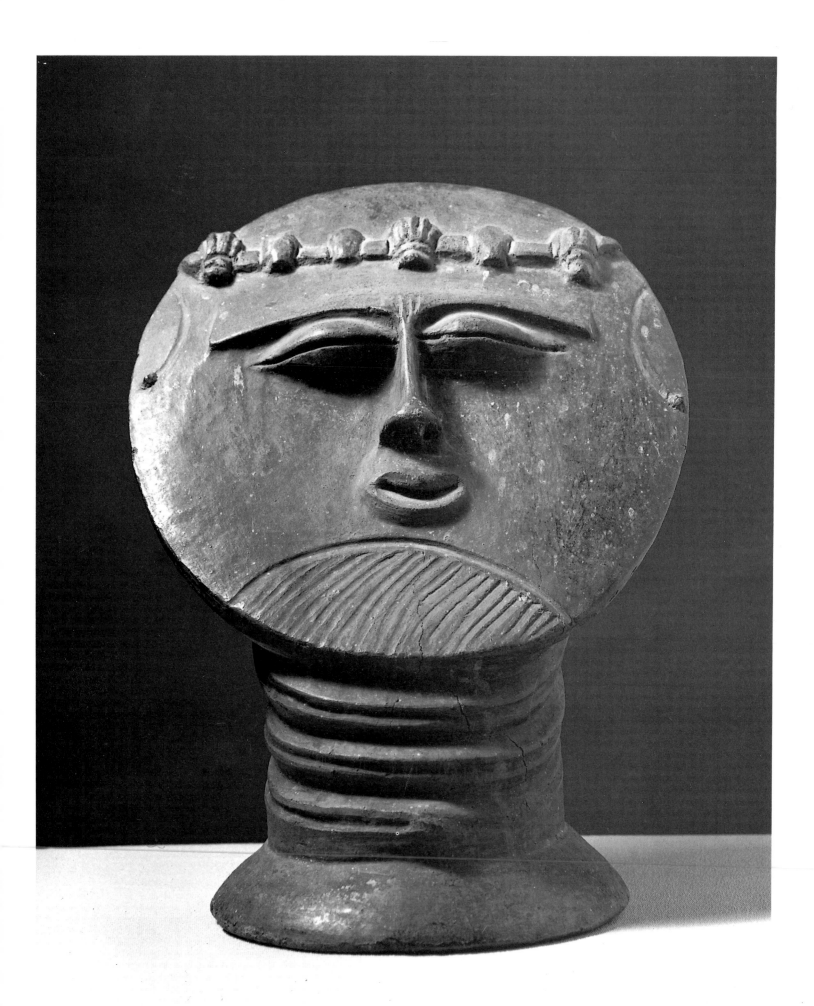

48

28. *Ghana, Akan*
Commemorative Head
Terracotta
H. 14 in.
Chang Trust Collection

During the lifetime of a member of an Akan royal lineage, a female artist modeled a sculpture in his or her image. Akan ceramicists never worked from drawings or models, and created portraits that tend to be somewhat idealized visions only slightly individualized. They range from life-like naturalism to extreme stylization, as here, with a flat disc-shaped face on a columnar ringed neck. The subject of the portrait is nevertheless always recognizable to family members by the details of scarification, jewelry, coiffure, and other personal embellishments.

33. *Nigeria, Yoruba*
Kola Bowl
Wood
H. 6¾ in.
Jay and Clayre Haft Collection

Kola, a sacred white substance for the Yoruba, plays a critical role in Ifa divination and is kept in a bowl that the diviner designs and sometimes carves himself. The works of art used in the process of Ifa divination are an important part of the imagery on the support of this bowl. A diviner, wearing a beaded bag around his neck, sits with an attendant to his side, a divination tray with Eshu's head lies before him, and a Kola bowl from which he draws the sacred powder is at his side. Kola is used both as an offering to the spirits and as a chalk for the tray in which the diviner records god-given messages. (*Sources for nos. 33–36: Fagg and Pemberton 1982. See fig. 8.*)

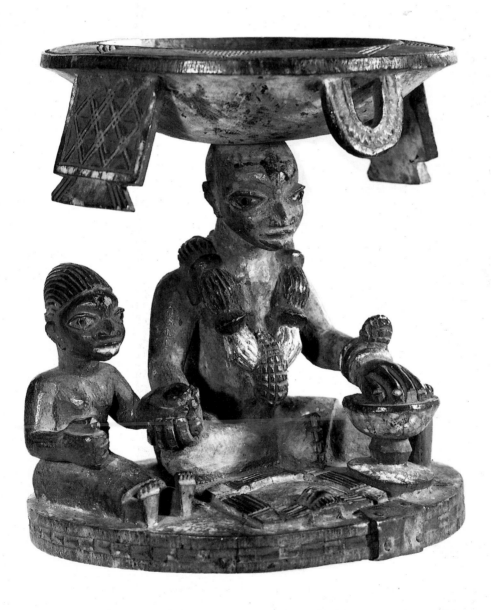

49

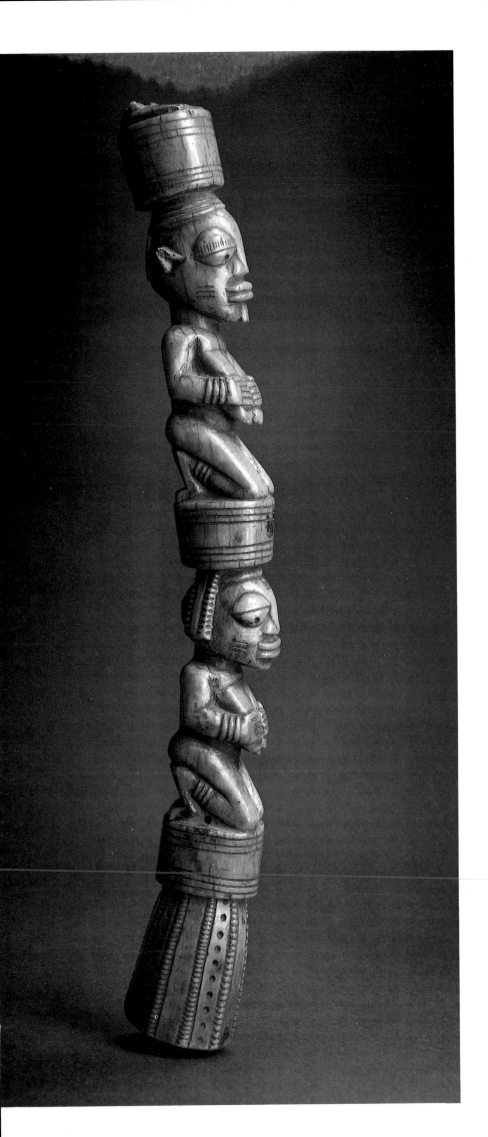

34. *Nigeria, Yoruba*
Divination Tapper
Ivory
H. 13¾ in.
Drs. Daniel and Marian Malcolm Collection

Both priest and doctor, the Yoruba diviner is trained to identify the source of illness, death, or sorcery through a complex system of foretelling known as Ifa. At the beginning of a consultation with a client, a diviner lightly strikes an ivory tapper like this one against a wooden tray (no. 36) to invoke the gods who were present at the moment of creation. Here, two sculptured female figures represent all devotees of the Ifa cult. The nude figures kneel because, as the Yoruba believe, each individual enters the world in a kneeling posture to learn his or her own destiny; the sculptural figures hold their breasts to convey humility and supplication.

35. *Nigeria, Yoruba*
Kola Bowl: Equestrian
Wood
H. 10½ in.
Hammer Collection, Chicago

The male equestrian is one of the most popular themes in Yoruba art, because of its historical significance and its aesthetic appeal. During the wars of the 17th and 18th centuries, the horse was one of the principal means of Yoruba expansion. Later, the ownership of a horse became a royal prerogative, signifying wealth, worldliness, and mobility. The equestrian—who is simultaneously elevated, seated, and supported—is therefore an ideal symbol of status. Here, a sensitive, detailed rendering of a mounted warrior in elaborate military garb supported an Ifa divination bowl (now missing).

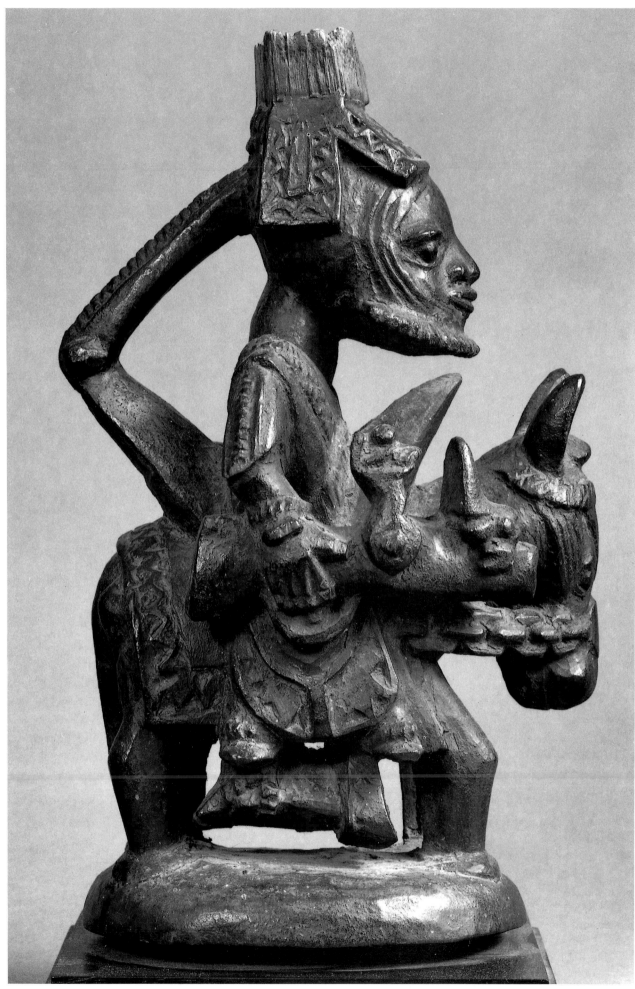

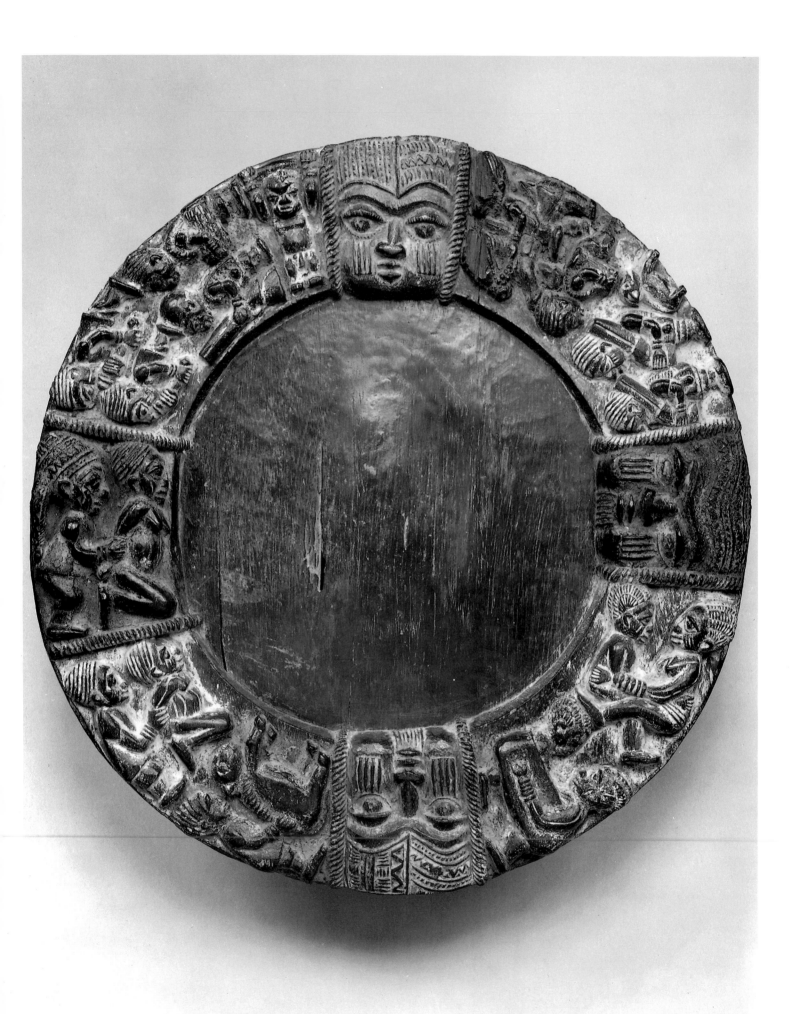

36. *Nigeria, Yoruba*
Divination Tray
Wood
D. 19 in.
Drs. Daniel and Marian Malcolm Collection

A carved, wooden tray is the pivotal instrument in an Ifa divination consultation. After spreading powdered kola nuts across the tray's surface, the diviner records numerologically significant patterns in the chalky coating. He then interprets these graphic symbols according to hundreds of sacred verses he has memorized and relates the message to his client. Royal attendants, soldiers, equestrians, musicians, and copulating couples in a balanced composition encircle the rim of the tray. Most notable are the three large, frontal faces representing Eshu, god of chance and uncertainty. Through Eshu's mystical abilities, Ifa divination reveals the secrets of fate and the potential for changing it.

41. *Nigeria, Benin*
Head
Bronze
H. 9 in.
Private Collection

The ultimate symbols of power in Benin Kingdom were representations of past rulers in the form of human heads. Three types—in bronze, wood, and clay—were displayed on the altars of kings, chiefs, and bronze casters, respectively. While the three types were never viewed together as a group, the Bini people associated each with a different degree of authority in the rigid political hierarchy of their society. Bronze heads were the most prestigious, since bronze was an expensive, imported material, and the casting technique was demanding. The extremely thin casting and naturalism of this head connect it with the earliest period of the kingdom (between the 14th and 16th centuries). There is some evidence that the heads originally represented trophies of war and sacrifice; only later did they acquire a commemorative function. (*Source for nos. 41–43: Schaefer 1983. See fig. 1.*)

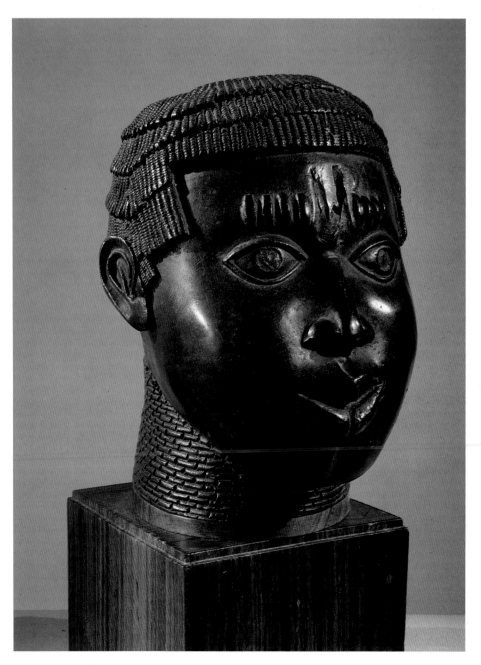

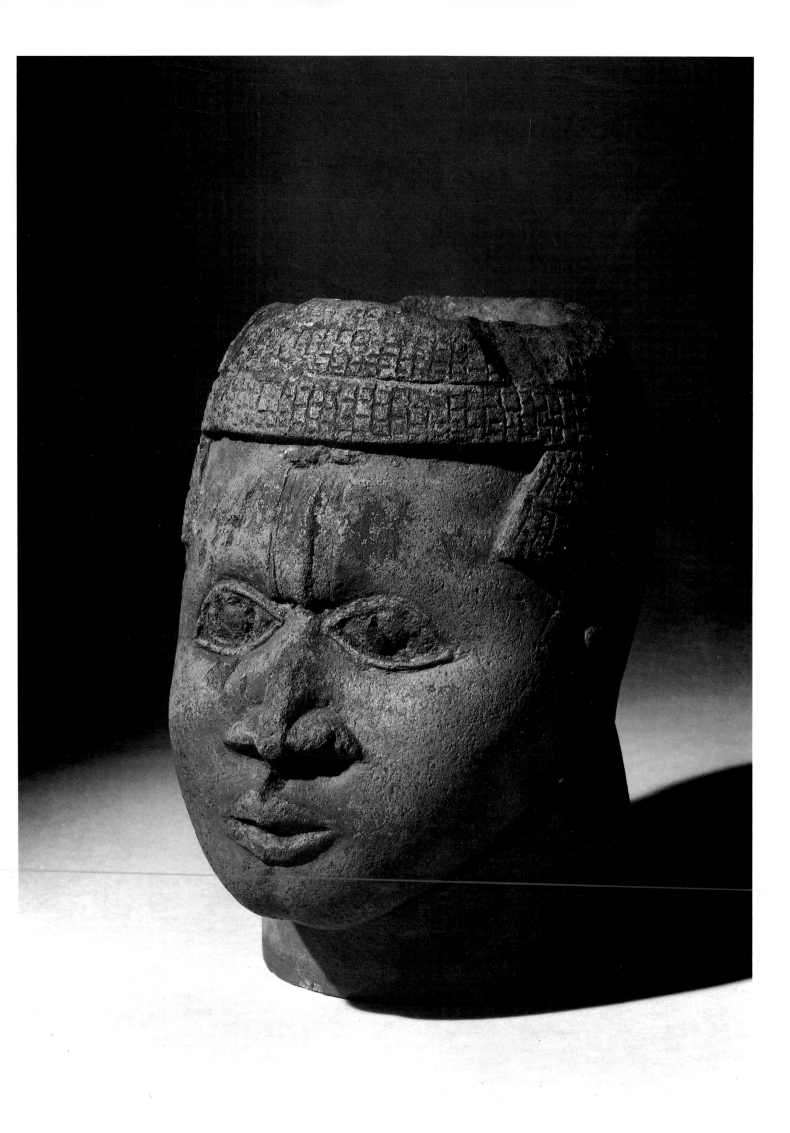

42. *Nigeria, Benin*
Head
Terracotta
H. 9 in.
Private Collection

As bronze heads (no. 41) began to indicate divine kingship, terracotta heads—once wide-spread symbols of office—were restricted to a select class of artisans. Bini bronze casters, believed to have learned the art of casting in metal from the master artists of the ancient religious city of Ife, were a highly venerated sector of the Benin royal community. They established their own altars and displayed there heads modeled in terracotta to commemorate the divine ancestors, from whom they drew their inspiration. Clay heads of the early period are very similar to the bronze heads, with natu-ralistic proportions and youthful forms. The open, staring eyes, flawless features, and expressionless face of this example convey a sense of timelessness. While terracotta heads signal a separate and less omnipotent power than the bronze versions, they nevertheless reveal the important place of the artist in Benin society.

43. *Nigeria, Benin*
Head
Wood
H. 26½ in.
Merton D. Simpson Gallery Collection

Oral tradition relates that during the late period of the Benin kingdom (17th–19th centuries), chiefs under the king requested the right to display wooden human heads on their own altars. These heads replaced representations of sacrificial rams and became new symbols of sacrifice. The stylization and rigidity of this head identify it with the late Benin period and reflect the kingdom's increasing militarism and imperialism. The cap and collar here occupy two-thirds of the composition, while the face is compressed and conventionalized. The human-istic quality of the early-period heads is here re-placed by an imposing image of power. These wooden heads reflect a parallel development in the late-period bronze heads, which also be-came heavier, more elaborate, and more massive.

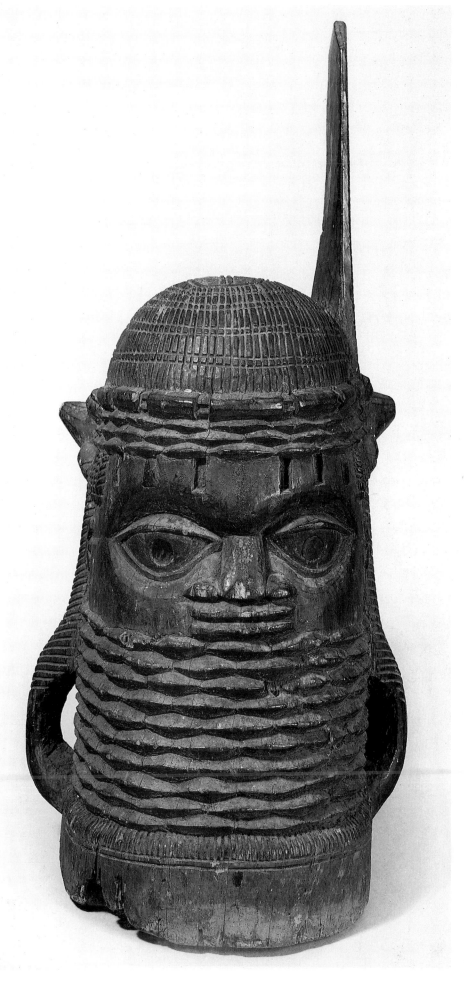

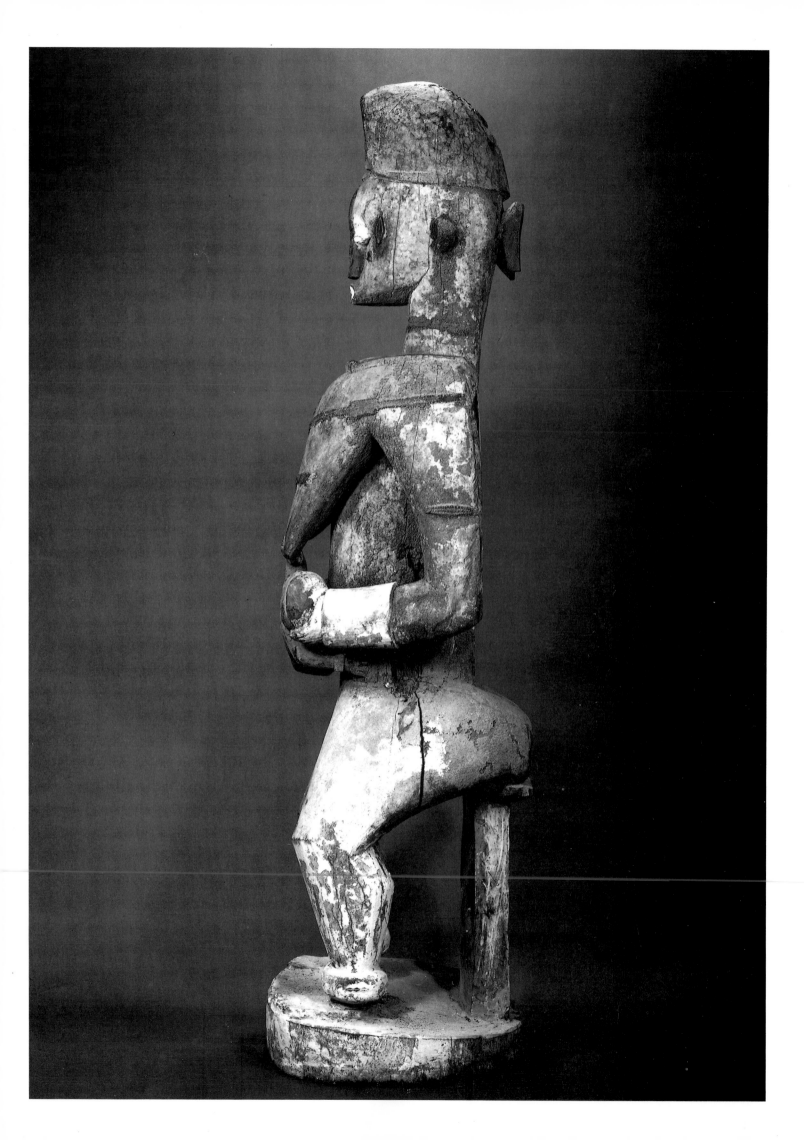

49. *Nigeria, Urhobo*
Shrine Figure
Wood, pigment
H. 81 in.
William and Niki Wright Collection

As many as twelve monumental male and female figures may stand together in shrines to commemorate the spirits that pervade all life in the Urhobo universe. Some honor the spirits of the earth, who, it is believed, reside in lakes, trees, rivers, and fields, while others, like this one, embody less tangible forces. Their representation in human form reflects the view that a society is a microcosm of the natural and supernatural realms, and that stability at the human level will assure order and harmony elsewhere. (*Source for nos. 49–51: Foss 1976.*)

50. *Nigeria, Urhobo*
Shrine Figure
Wood, pigment
H. 80 in.
Mr. and Mrs. John N. Rosekrans, Jr. Collection

Based on the family model, Urhobo shrine-figure groups characteristically have one central male figure surrounded by his wives, children, and attendants. This central figure, a large, muscular male with a swelling chest and bared teeth, assumes an aggressive stance and bears the emblems of his rank as a warrior. Military prowess is a common theme in Urhobo iconography, since men in particular are associated with the land and with its protection. Women, in contrast, are identified with water and with its procreative powers. Urhobo shrine figures line the back walls of shrine houses, where they are only partially visible. Separating the viewer from the figures is a curtain made of mud and raffia, symbolizing the passage from the profane world into the sacred realm of the spirits. (*See fig. 2.*)

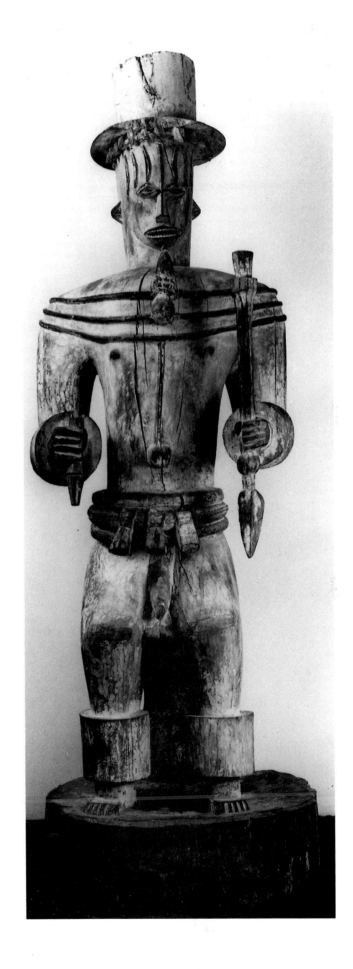

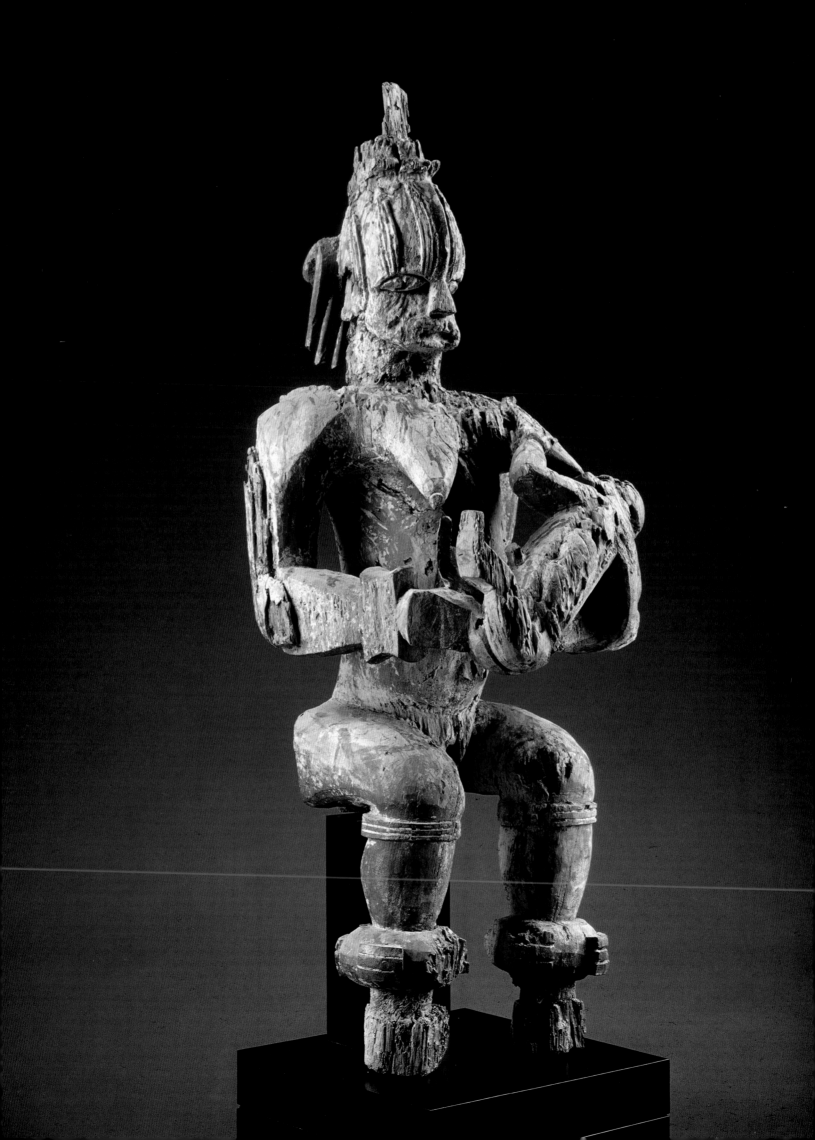

51. *Nigeria, Urhobo*
Shrine Figure
Wood, pigment
H. 55 in.
Philippe Guimiot Collection

It is hard to imagine this figure, with its thrust-
ing volumes and full expansive muscles,
crowded into a dark enclosed space with twelve
other similar figures. Larger than life, it stands
as a monument to the exalted state of mother-
hood. In its original setting, together with other
sculptured family members, it symbolized sta-
bility and the perpetuation of the group as a
whole. (*See fig. 3.*)

54. *Cameroon, Mambila*
Figure
Wood, fiber, pigment
H. 11¼ in.
*Metropolitan Museum of Art, the Michael C.
Rockefeller Memorial Collection, Fletcher Fund
purchase*

Photographed in situ, and collected by Paul
Gebauer in 1936, this figure is unusual in being
documented to the headman's shrine in Kabiri
village. Its vestigial arms and startled expression
gain significance when we see it as it originally
looked, grouped with others, and swinging
beneath the elevated shrine (fig. 6). Information
on the exact meaning of individual figures is
unclear: some were guardians of the shrine
while others were the abodes of ancestral
spirits. (*Sources for nos. 54–56: Gebauer 1979;
Schwartz 1972. See fig. 4.*)

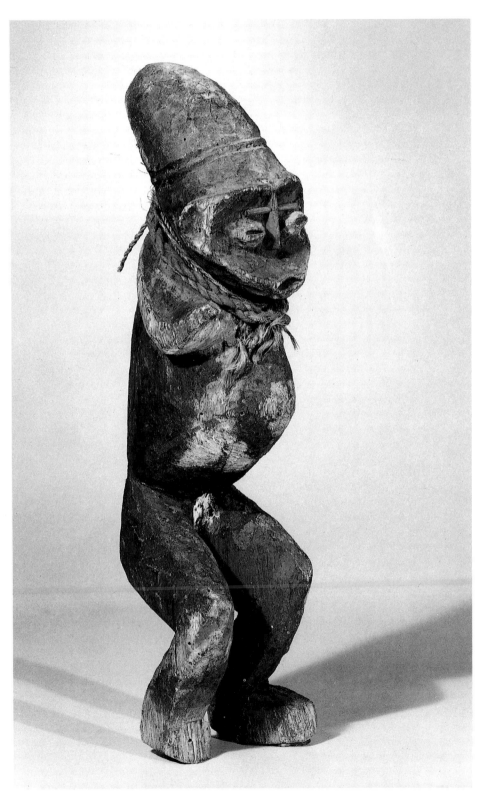

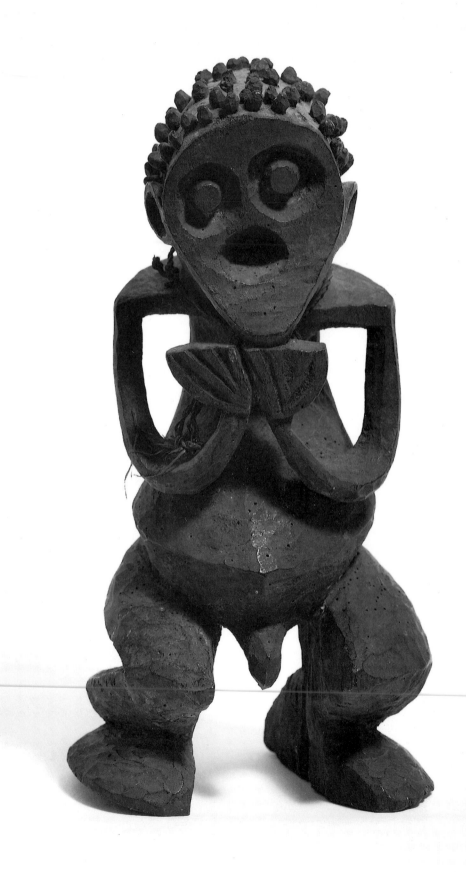

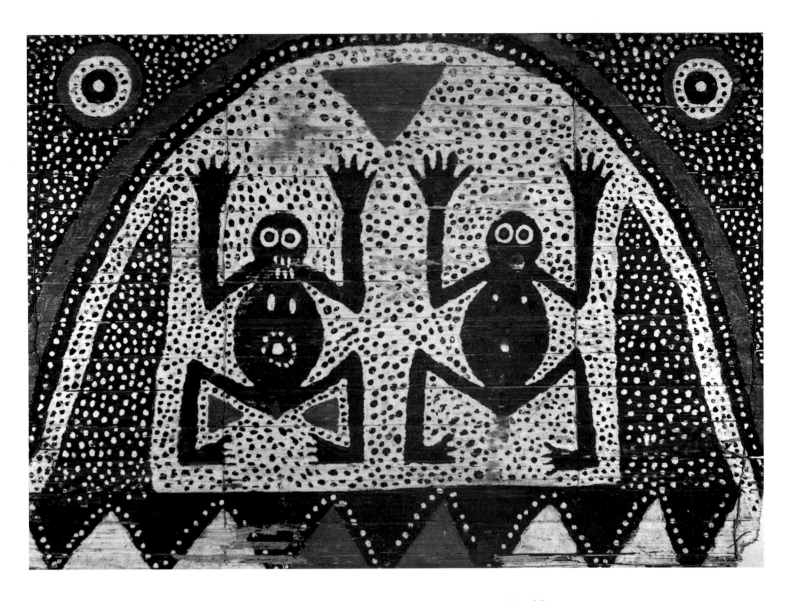

56. *Cameroon, Mambila*
Painting
Bark, paint
L. 45 in.
William Arnett Collection

55. *Camerôon, Mambila*
Figure
Wood, fiber, pigment, and feathers
H. 11¾ in.
Private Collection

In Mambila ancestor shrines, anthropomorphic
sculptures made of wood and raffia-palm pith
are caught in a net that supports them in front
of a painted wooden screen (no. 56). The figures
do not represent specific ancestors, but rather
are a metaphor for the collectivity of ancestors
who intercede in the affairs of the living. Once
painted in the ritual colors of red, black, and
white, this figure, along with others, formed a
vibrant image with the painted screen backdrop.

The Mambila display their ancestor figures (no.
54) in front of simple, painted screens like this
one, which decorate the facades of small, ele-
vated shrine houses. The paintings usually
show a male-female pair encircled by the cosmic
forces of the universe—the sun, the moon, and
a rainbow. At the center and just above the
figures in this example is a triangle, symbol of
the village compound. This integrated composi-
tion expresses the belief that the community is a
microcosm of the universe, and that each indi-
vidual serves as a link between spiritual and
earthly realms.

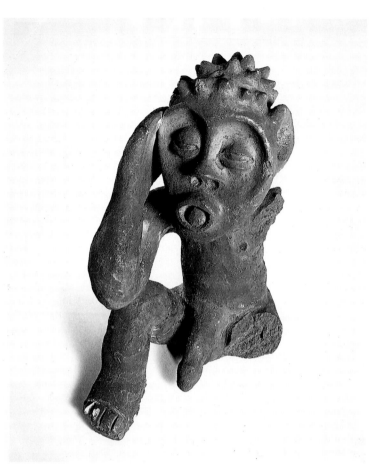

57.–58. *Cameroon, Mambila*
Pair of Figures
Terracotta
H. 10 in. (f.), 9½ in. (m.)
Philippe Guimiot Collection (f.), The Portland
Art Museum, Paul and Clara Gebauer Collection (m.)

While most Mambila works of art are displayed outside the ancestor shrine, pairs of terracotta figures are kept inside along with masks, fiber costumes, and other ritual equipment. Among these are rare terracotta figures whose significance is unclear, but whose form is highly expressive. This sensitive pair is among the most finely modelled of those known. They were hidden within an enclosure forbidden to women; only a few men were privy to their significance. African ensembles often include both publicly viewed and privately concealed works of art, reflecting unequal access to higher knowledge.

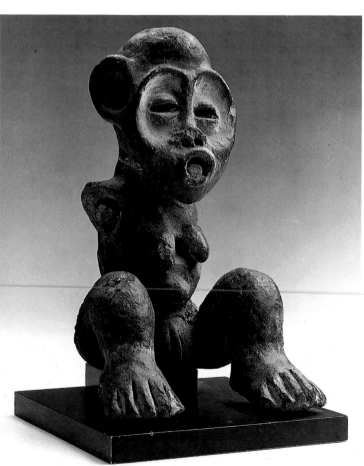

59. *Cameroon, Mambila*
Male figure
Pith, pigment
H. 13 in.
Metropolitan Museum of Art. Lent by Clara Gebauer, Walter Gebauer, and Anne Gebauer Hardy

Mambila pith figures are unusual in African art in being composed of numerous joined pieces. The body and head are made of three palm ribs, the top of the head (in this case), as well as the arms and other appendages are carved separately and attached with slender pegs. Earth pigments define the parts of the body and decorate it with stars and dots. Displayed on the outside of the shrine, pith figures are exposed to the elements and rarely last more than a few years. No effort is made to prevent their decay.

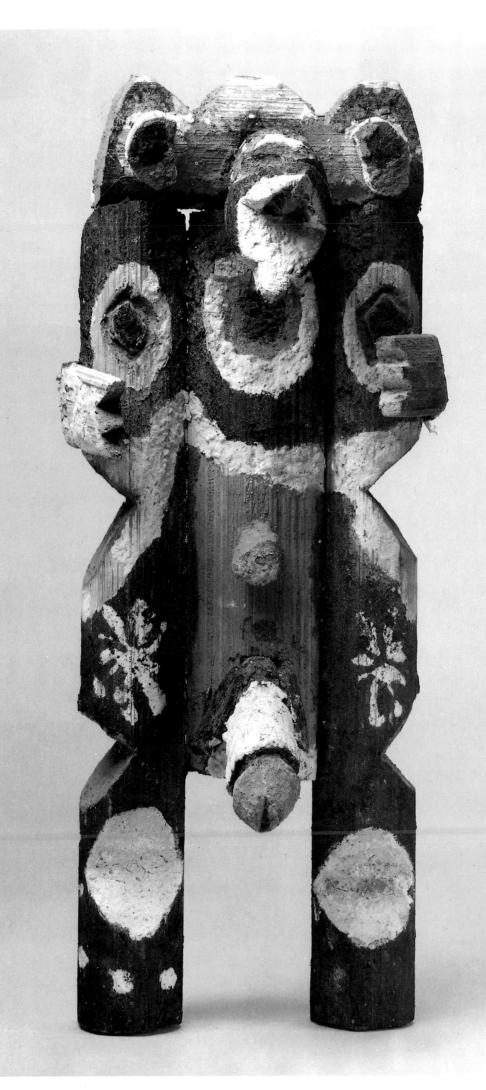

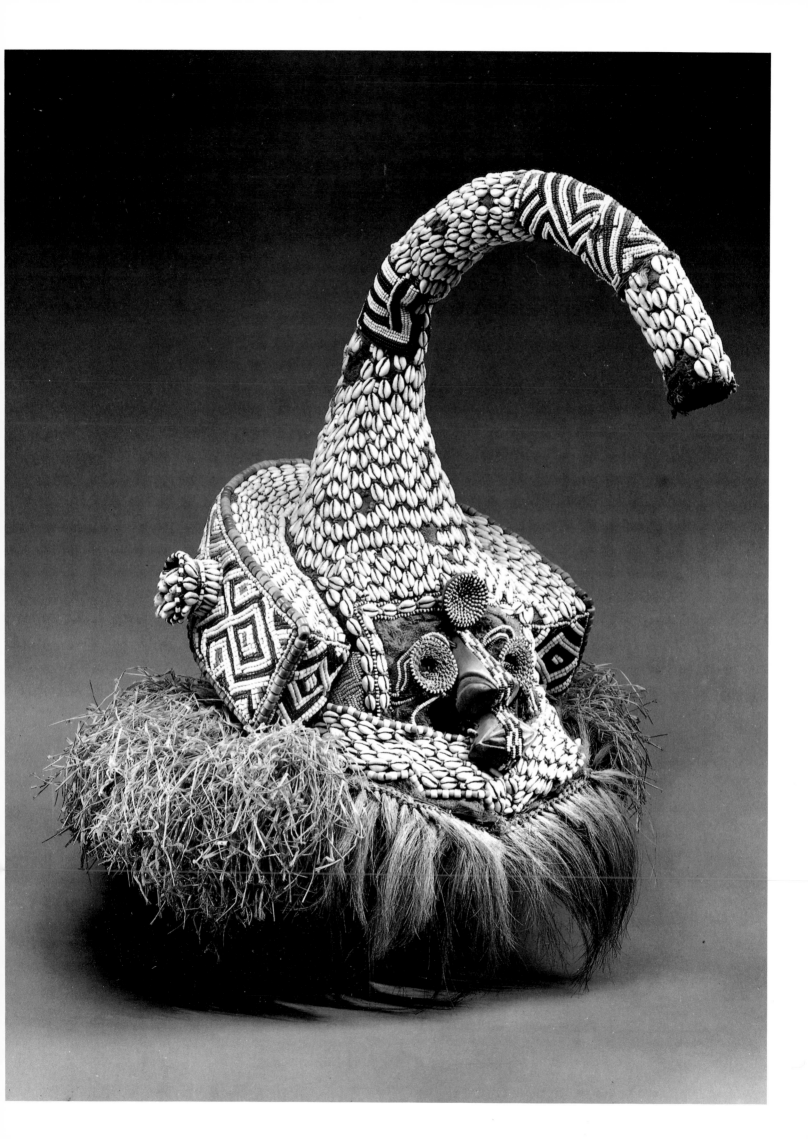

63. *Zaire, Kuba*
Mask: Mwash a Mbooy
Wood, beads, cowrie shells, cloth, and raffia
H. 18 in.
Frieda and Milton F. Rosenthal Collection

The Kuba, a confederation of ethnic groups in
south central Zaire, have masking traditions that
relate both to royalty and mythology and that
characteristically involve a triad of masks. This
spectacular beaded mask represents the central
character, who is both founder of the Kuba
kingdom (Woot) and creator of mankind
(Mwash a Mbooy). Mwash a Mbooy was the
king who introduced royalty and the arts of
civilization—weaving, agriculture, and iron
working. He is represented in the mask as an
elephant, a metaphor for the strength and
authority of the king. At the funeral ceremony
of a king, his successor wears this mask to
assume the power of Woot, and to symbolize
the continuity of the royal line. (*Sources for nos.
63–65: Cornet 1982; Vansina 1955.*)

64. *Zaire, Kuba*
Mask: Ngaady a Mwash
Wood, beads, pigment, cowrie shells, and cloth
H. 13½ in.
Private Collection

The beautiful woman over whom Mwash a
Mbooy (no. 63) and Mboom (no. 65) are said to
have fought is represented ritually in this richly
beaded mask, called Ngaady a Mwash. Histori-
cally, she was Mwash a Mbooy's wife, although
she was also the object of his brother Mboom's
love. Cosmologically, she is the sister of the
creator, Woot, and is associated with water and
the forest. The embroidered tracery of imported
beads and shells are reminiscent of Kuba textile
patterns and exemplifies the Kuba desire to
cover surfaces with aesthetically pleasing deco-
rative patterns. Through the performance of
these three types of masks, the Kuba reenact the
mythical creation of the world and dramatize
the origins of Kuba kingship. (*See fig. 9.*)

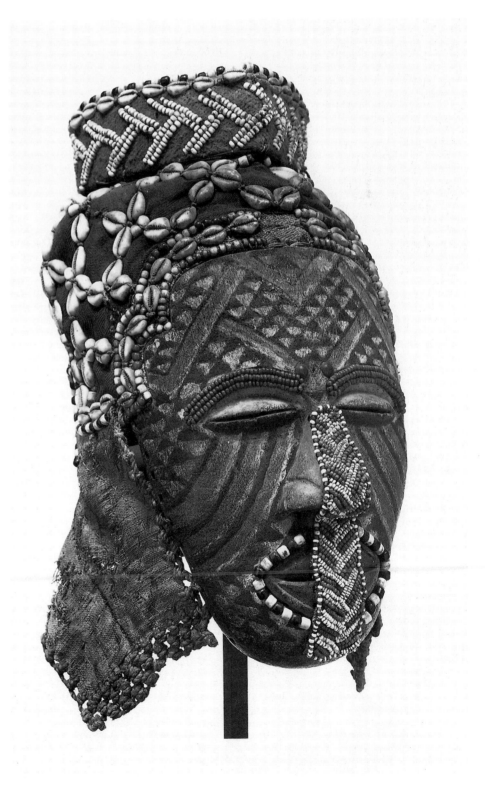

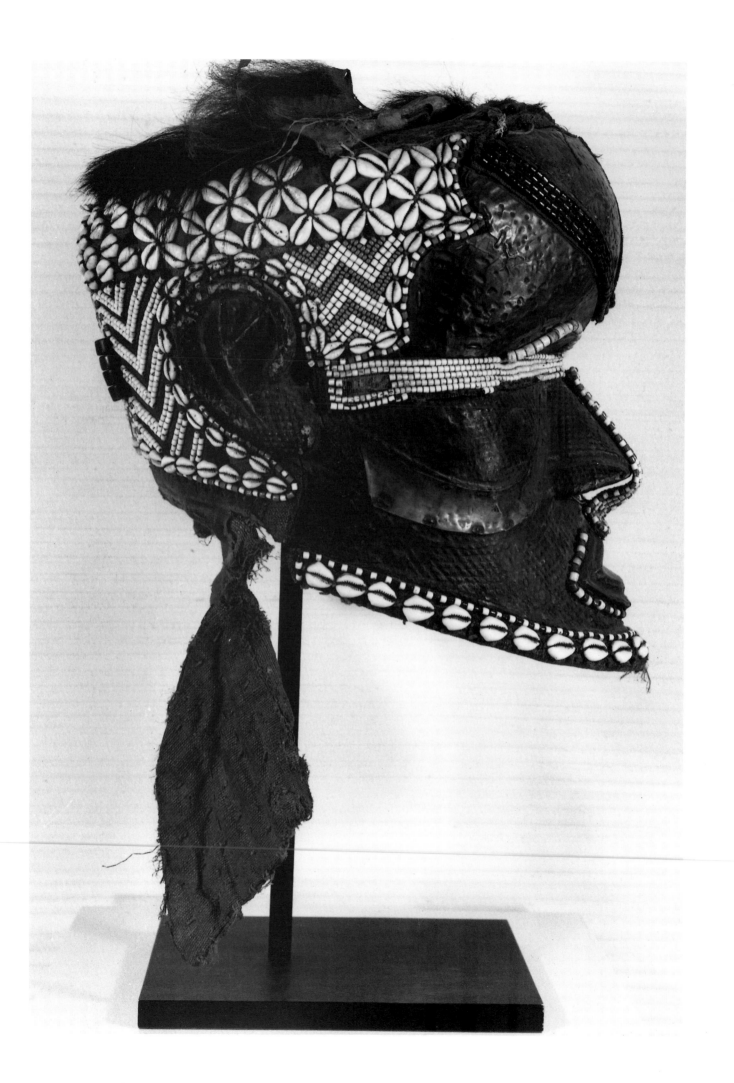

65. *Zaire, Kuba*
Mask: Mboom
Wood, beads, copper, leather, cloth, cowrie shells,
and fur
H. 13 in.
Private Collection

In Kuba initiation and funeral ceremonies, this
mask, called Mboom, represents the classic
anti-hero. Traditionally, Mboom is thought to
have been the younger brother of Mwash a
Mbooy (no. 63), with whom he competed for
the throne and for the love of Ngaady a Mwash
(no. 64). Mboom also represents the values and
sentiments of humble commoners outside the
palace who are excluded from royal rights and
are powerless subjects under the divine author-
ity of the king. Mboom threatens Mwash a
Mbooy with his pretention to the throne and
reminds the king of the need to constantly reaf-
firm his royal prerogatives. When worn at the
initiation rites of young boys, both masks serve
as police officers, playing terrorizing figures
from the past. (*See fig. 9.*)

66. *Zaire, Salampasu*
Female Figure
Wood, Paint
H. 68 in.
Mr. and Mrs. Gerald Dannenberg Collection

On a symbolic level, Salampasu masked
dances—with their male and female orches-
tras—are an expression of ancient rivalries
between men and women. While there is an
elaborate hierarchy of male masks—differenti-
ated by their colors, materials, and props—
women dance without masks. A large sculpture
of a woman does, however, play a part in the
performance. Here the face is identical to those
of the masks, with a very long straight body
and unusually realistic proportions. (*Sources for*
nos. 66–68: Bogaerts 1950; Clé 1948. See fig. 13.)

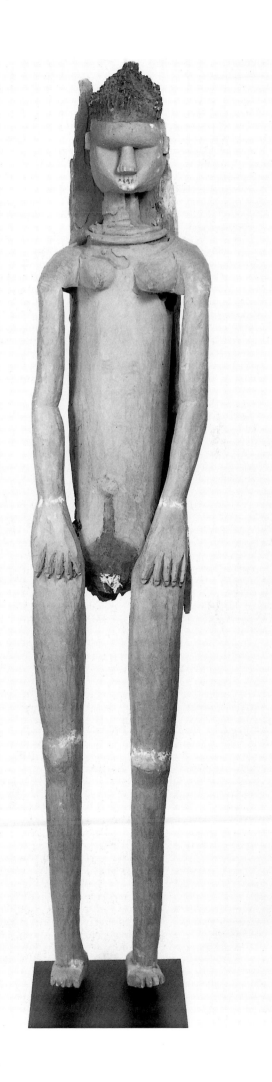

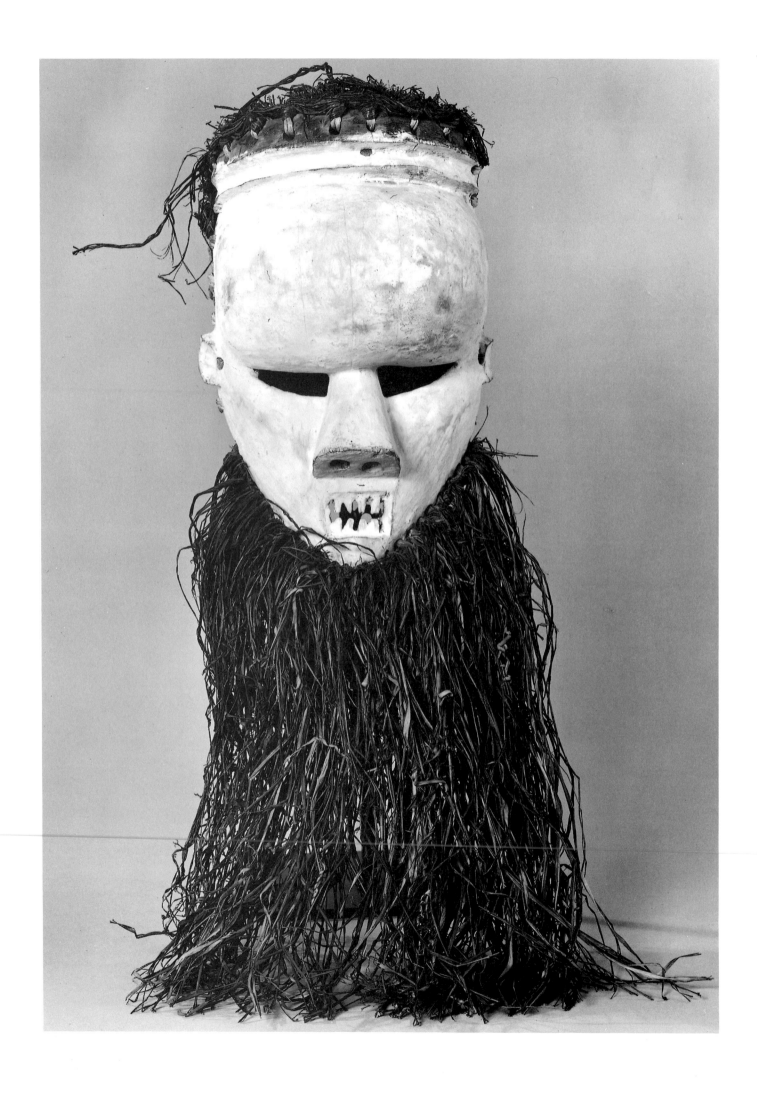

67. Zaire, Salampasu
Mask
Wood, raffia, and kaolin
H. 23½ in.
The University of Michigan Museum of Art
Collection. Purchase made possible by the
Friends of the University of Michigan Museum
of Art

Among the Salampasu, a hierarchy of masked
dancers performs both secular and sacred func-
tions. As in many non-stratified societies, masks
replace police and courts of law as instructors,
law-enforcers, and guardians of secret knowl-
edge. Masks are also embodiments of spirit,
and are used for religious purposes and rites of
transition. Initiation ceremonies and funerals, in
particular, are consummated only with the aid
of these spirits who assure the safe passage of
an individual from one state of being to another.

68. Zaire, Salampasu
Mask
Wood, pigment
H. 11 in.
Mr. and Mrs. Harold Rome Collection

In addition to their didactic and police roles,
Salampasu masks appear in the context of a
men's secret association of assassins. In many
societies, ritual combat, assault, and murder are
a means of expressing aggressions that might
otherwise result in actual warfare or compulsive
crime. By institutionalizing these acts, they are
accepted as part of an elaborate ceremonial
cycle. Members of the association wore masks
such as this in rites to absolve the assassins of
their crimes.

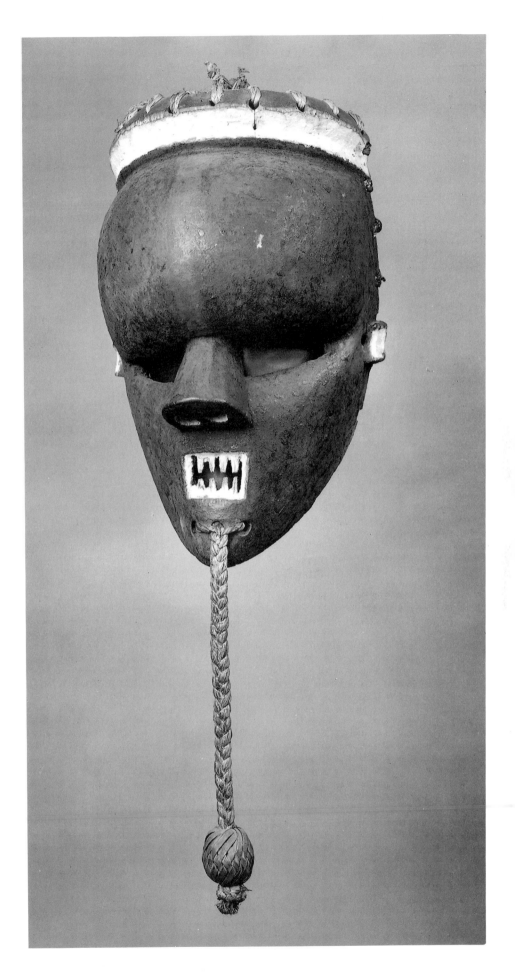

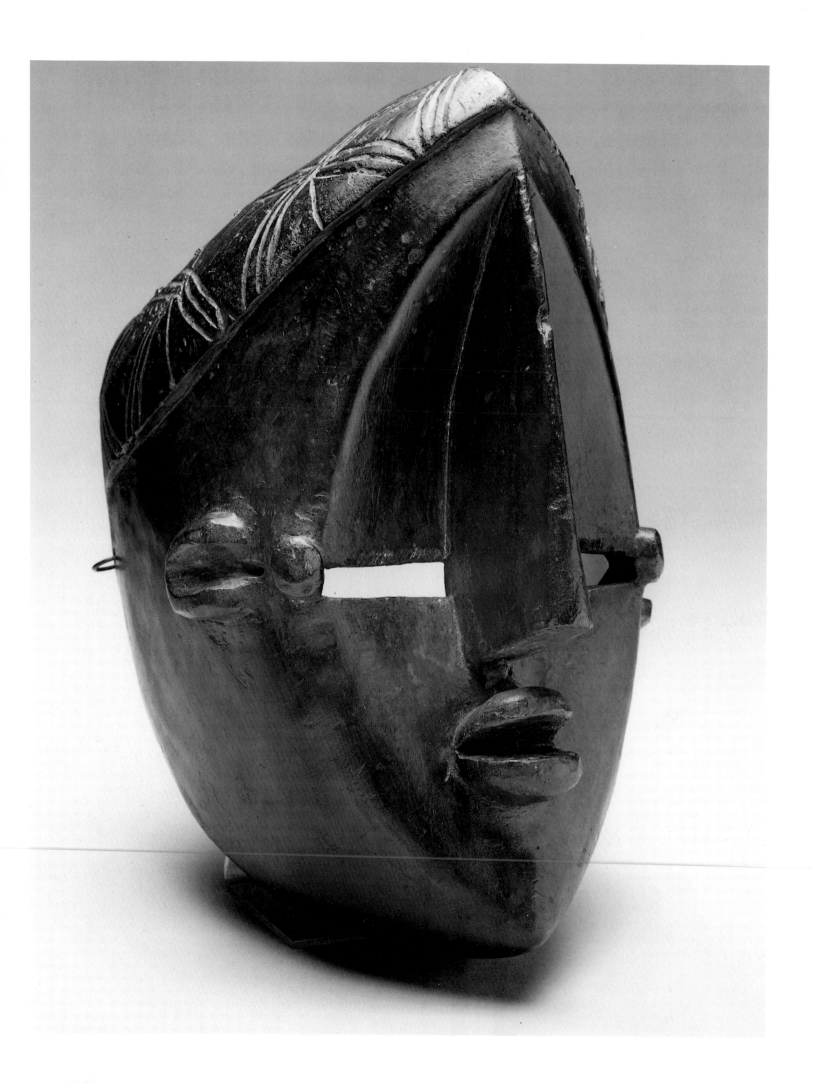

71. *Zaire, Lwalwa*
Mask
Wood, fiber
H. 11½ in.
Murray and Barbara Frum Collection

Lwalwa artists represent the human face as a landscape where sloping planes meet steep inclines. They may have been an inspiration for Cubists of the early 20th century though their goals lie deeper than the purely formal concerns of the Cubists. The subtlest rearticulation of features in a Lwalwa mask can alter its meaning. Indeed, the four principal characters in Lwalwa dances—hunter, chief, diviner, and woman—are distinguished from one another by modifications in form so slight—for example, a shift in the point where the nose meets the forehead—that they might escape the untrained eye. (*Source for nos. 71-72: Timmermans 1967.*)

72. *Zaire, Lwalwa*
Male Mask
Wood
H. 12½ in.
Mr. and Mrs. Harold Rome Collection

Lwalwa masks perform when a hunt has been unsuccessful and help is sought from the ancestors. In order of ascending status, three archetypal masks (hunter, diviner, and chief) and one female mask (distinguishable by her crested coiffure) dance to the accompaniment of an orchestra composed of male and female instruments. Each masked dancer manipulates specific props, and certain of them perform dramatic gymnastic feats, including standing somersaults. It is thought that, by reenacting the social hierarchy, these masks restore order and balance to the world.

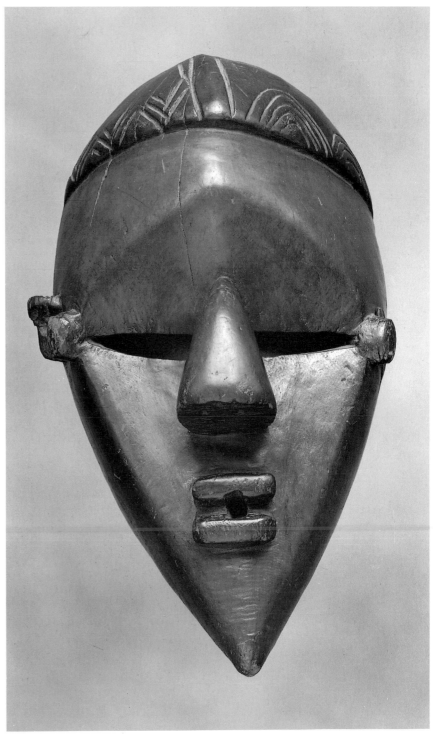

71

75. *Zaire, Luba*
Stool
Wood
H. 16½ in.
University Museum Collection, University of Pennsylvania

This stool was probably carved by an artist at the royal court since works of art attributed to him (no. 81) once formed part of the royal treasury. His hand is recognizable by a large round head with a rectangular chin, a low-hanging coiffure, the reduction of the legs to diminutive snake-like forms, and the dense, yet detailed, patterns raised in relief on the torso. This superb artist makes the disproportionate parts of the body seem completely natural, and the supporting posture graceful and poised. The contemplative attitude of this figure must have lent dignity to the ruler it upheld, and the shiny black patina reflected the care its owner took to keep it beautifully oiled. (*Source for nos. 75–81: Nooter 1984.*)

76. *Zaire, Luba*
Ceremonial Axe
Wood, metal
H. 15 in.
Max Granick Collection

Ceremonial axes are often worn over the shoulders of Luba kings, chiefs, and counselors as a sign of status and wealth. Their symbolic rather than utilitarian purpose is indicated by their blunt blades, copper-wrapped handles, and the addition of a finely sculpted female head. Such axes, together with other insignia that is worn or displayed, contribute to the visual enhancement and metaphorical extension of a ruler. The use of elaborate axes as prestige paraphernalia goes back to the 11th century at least, for archaeological excavations in the area have uncovered graves of high-ranking persons with whom such axes were buried as offerings.

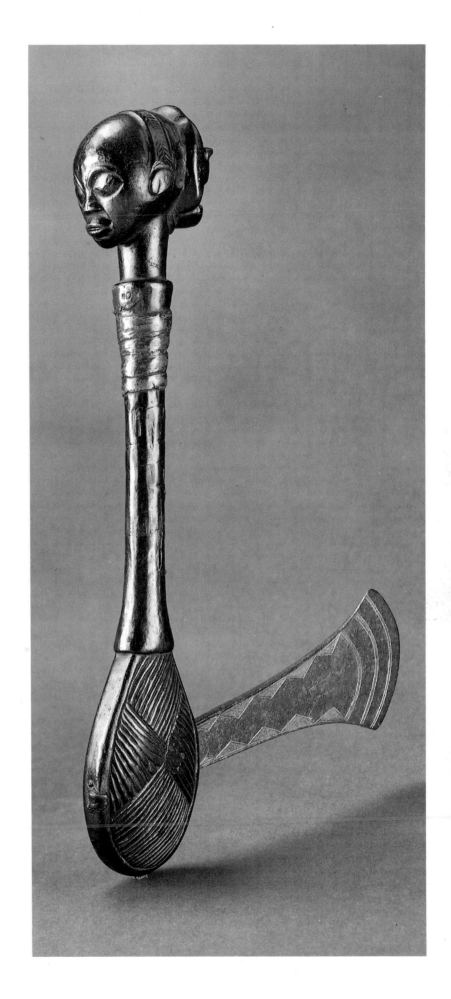

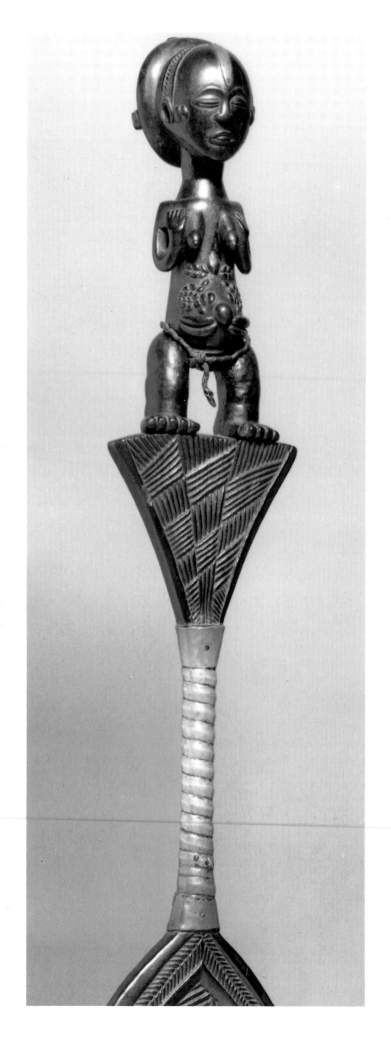
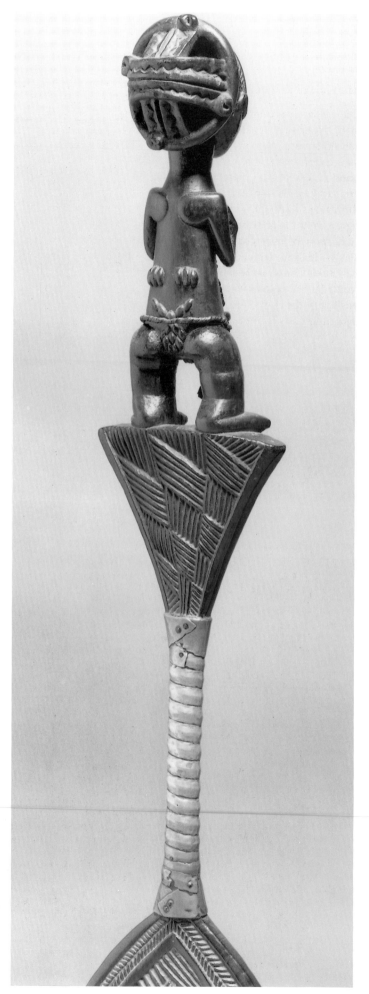

74

77. Zaire, Luba
Staff of Office
Wood, metal, fiber, and leather
H. 55¾ in.
Murray and Barbara Frum Collection

During the investiture ceremony of a Luba king, staffs, along with spears, bows, and stools, were carried by royal women in procession. A staff such as this one was placed in the king's right hand as he swore his oath to office, and it appeared by his side at all state occasions throughout his reign. The full-length female figure on this staff distinguishes it as a king's staff; those of lesser chiefs and counselors are simpler in form, with only a female head. The king's possession of the most ornate and highly worked regalia expresses and reinforces his position at the apex of the social and political pyramid.

78. Zaire, Luba
Royal Cup
Wood
H. 4 in.
The Metropolitan Museum of Art, The Michael C. Rockefeller Memorial Collection, Nelson A. Rockefeller Gift.

The Luba believe that a king's power is often transmitted to his successor through contact with his head, which is thought to be the locus of divine wisdom and strength. For this reason, each new Luba king was required to consume blood from the cranium of his predecessor during the investiture ceremony. Exquisitely carved wooden head cups like this one may have been used in a recent modification of this tradition. That less than ten of these cups are known to exist may confirm their use in the one ritual that distinguished a king from all others—the awesome consumption of human blood—and would make these cups the most sacred of Luba insignia.

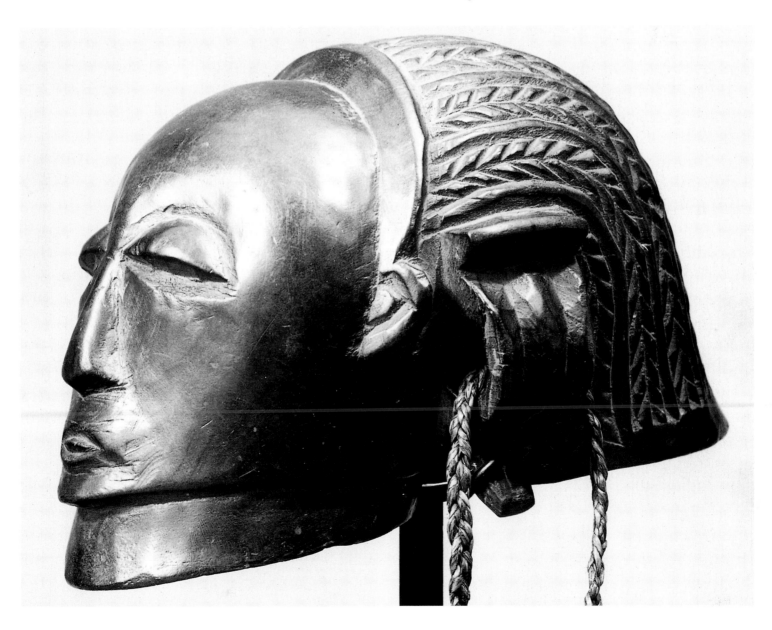

79. Zaire, Luba
Figure with Bowl
Wood
H. 14½in.
Department of Anthropology, American
Museum of Natural History

A bowl-bearing figure (*mboko*) was part of the
insignia of any Luba ruler, and was a requisite
for his investiture. If a chief or the king lost his
mboko, he was required to furnish another
quickly, for the *mboko* was the only tangible
proof of his authority. The female figure holding
this bowl may represent the ruler's first wife,
who served as the locus for his protecting spirit.
She has a high, rounded forehead; half-closed
eyes; smooth, glossy skin; and the elegant, four-
lobed coiffure typical of the region. This figure
was a gift to the museum from King Leopold of
Belgium around 1900.

80. Zaire, Luba
Stool
Wood
H. 15½ in.
Gustave and Franyo Schindler Collection

In Africa, the right to sit during ceremonial
occasions often distinguishes a person of high
status from a commoner; among the Luba, elab-
orate caryatid stools served as thrones. At the
enthronement of a new ruler, the stool was
placed on a leopard skin to prevent the king's
feet from touching the ground and to symbolize
his dominance over even the most lordly
of animals. Flanking the stool were other
emblems—a staff and a spear—which, like
the stool, were adorned with female figures.
Though they often assume supporting roles, the
female figures in Luba art are nevertheless royal
women, as evidenced by the richness of their
coiffures and scarification. They may be both
a generalized symbol of ancestral continuity,
and a specific reference to women leaders
who were influential in the expansion of the
Luba kingdom.

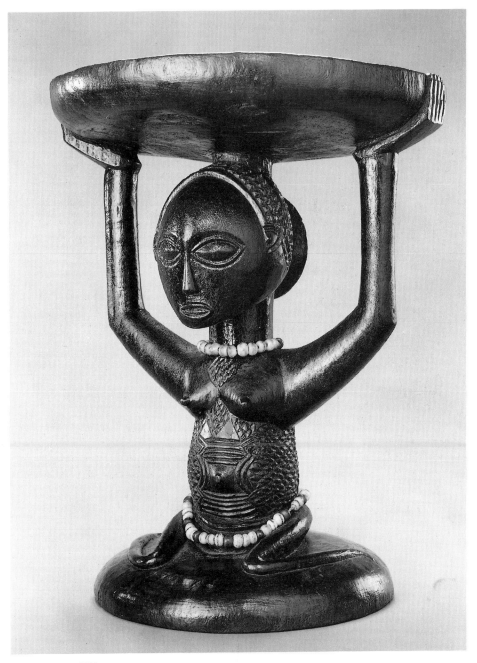

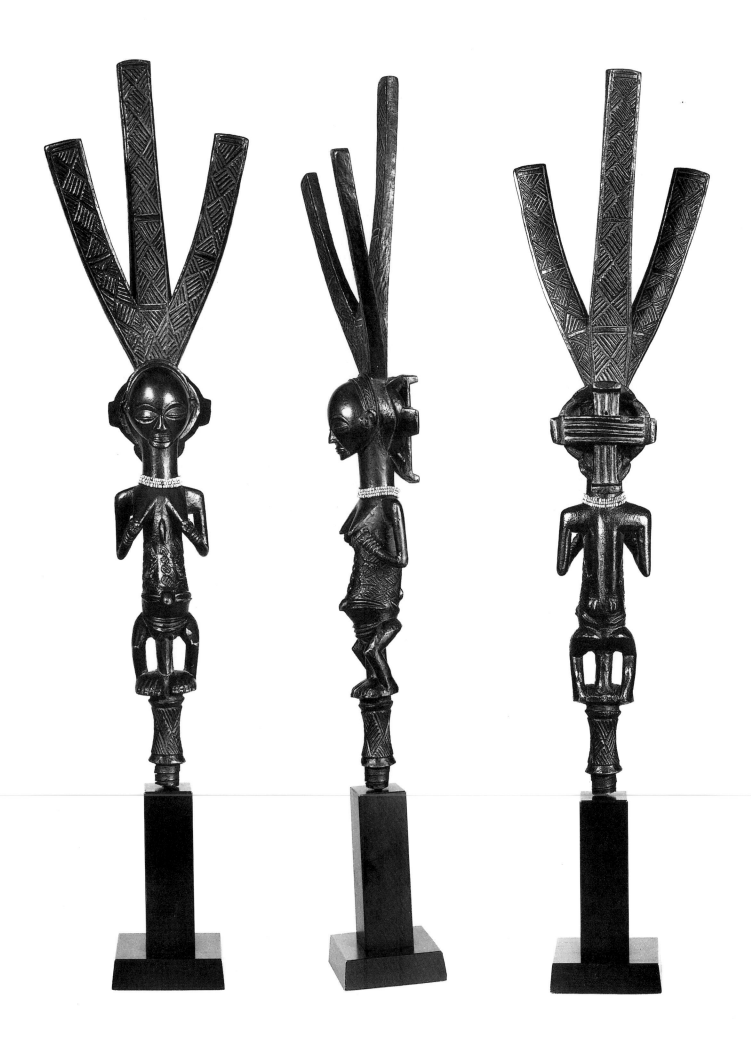

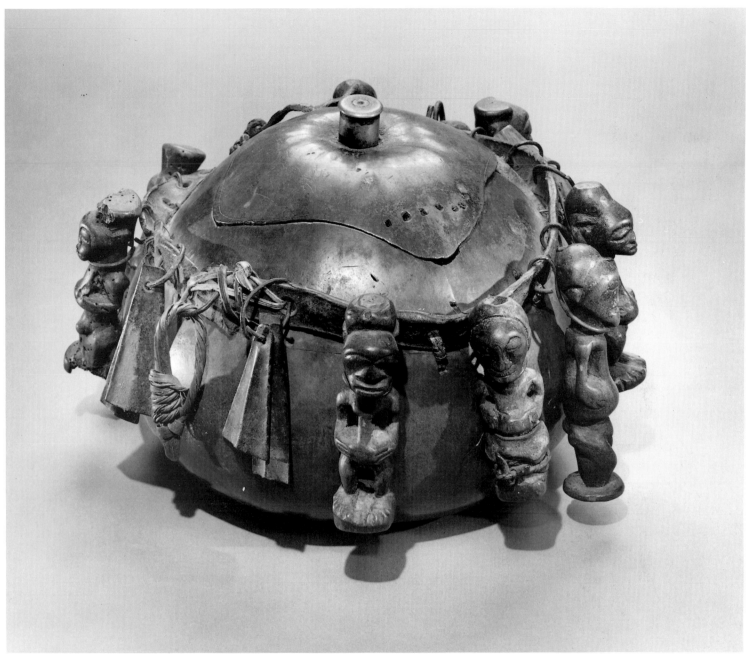

81. Zaire, Luba
Bowstand
Wood
H. 26 in.
Merton D. Simpson Gallery Collection

While Luba bowstands hold bows and arrows, they also form part of a royal treasury unique to southeastern Zaire. Bowstands are kept within private enclosures, along with relics and other emblems of past rulers, where they regularly receive sacrifices and prayers. This bowstand and the stool in this exhibition (no. 75) appear to have been carved by the same artist. His hand is recognizable in the high forehead and low coiffure of the female figure in both. These works suggest that a single master may have been commissioned to carve the entire set of emblems for a new ruler. Seven works may be attributed to this unusually gifted artist.

85. Zaire, Songye
Divination Kit
Gourd, wood, metal, fiber, leather, and other materials
D. 8½ in.
Private Collection

Songye diviners toss the items in this assemblage and interpret their fall to control the forces of evil that cause illness, misfortune and death. The figures encircling the rim of the gourd are miniature versions of large Songye power figures used to deflect evil and to contain life-force. The divination gourd is filled with an astonishing array of natural objects—bones, seeds, bird skulls, twisted vines, eggs, claws, and fangs as well as man-made objects such as carved drums, and figures. The tossing of these small symbols is likened to winnowing for it separates truth from falsehood.

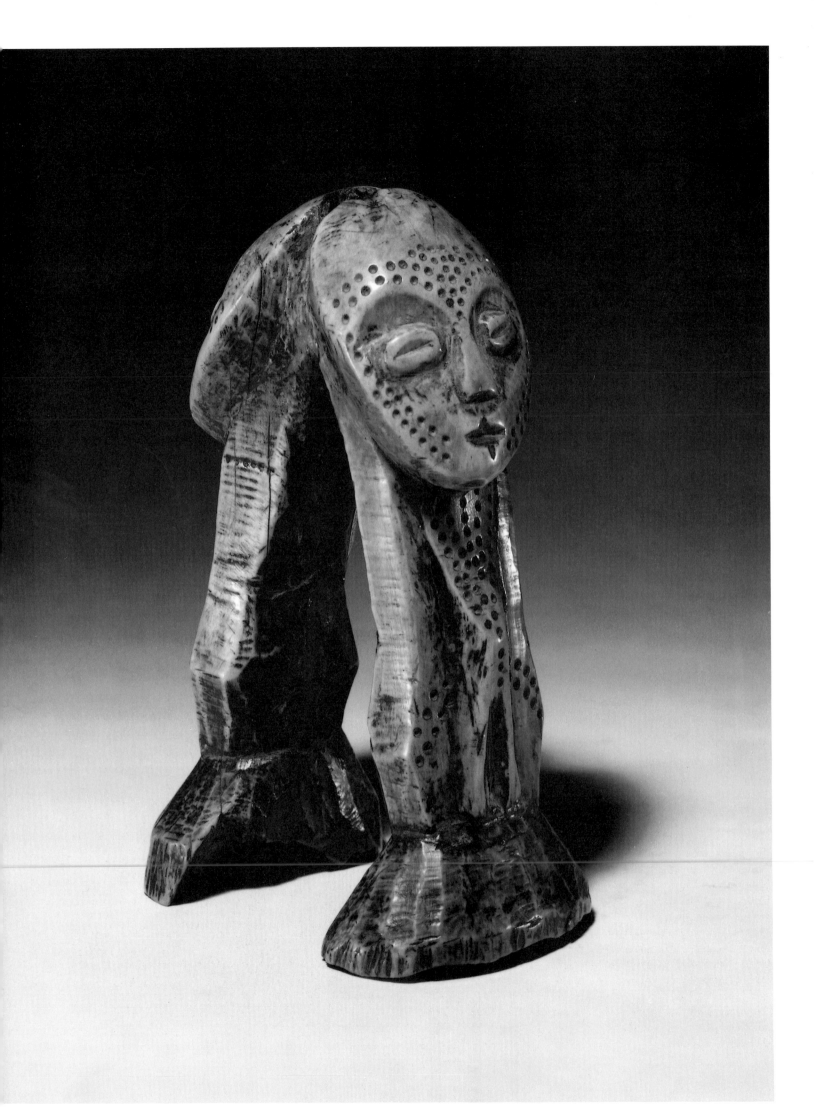

86. Zaire, Lega
Janus Figure
Ivory
H. 5½ in.
Jay and Clayre Haft Collection

Lega sculptures, particularly those in ivory, are
characterized by simplicity and schematization
of form. Only essential features are included,
for example, the head, while bodies and limbs
are reduced or completely omitted. These dis-
tortions are deliberate artistic choices intended
to convey invisible ideas through perceptible
forms. Ivory figures have strong life-force, espe-
cially when they are displayed on the tombs of
the deceased. Such figures are abraded and
their dust—imbued with the ancestors' ancient
wisdom—is consumed by initiates. (*Source for
nos. 86–92: Biebuyck 1973.*)

87. Zaire, Lega
Head
Ivory, cowrie shells
H. 8½ in.
Menil Foundation Collection

The essence of Lega life is advancement through
the grades of the Bwami initiation society.
Unlike most African initiation societies that are
restricted to adolescents, Bwami is a life-long
institution to which virtually all Lega men and
women belong. Each grade is identified with
groupings of particular emblems, both natural
and man-made. These assemblages are badges
of office, and aids for conceptualizing the teach-
ings of the society. Only members of the highest
grades are entitled to art works made of ivory.
Simplicity of form and glossiness of surface are
admired by the Lega, and characterize much of
their art.

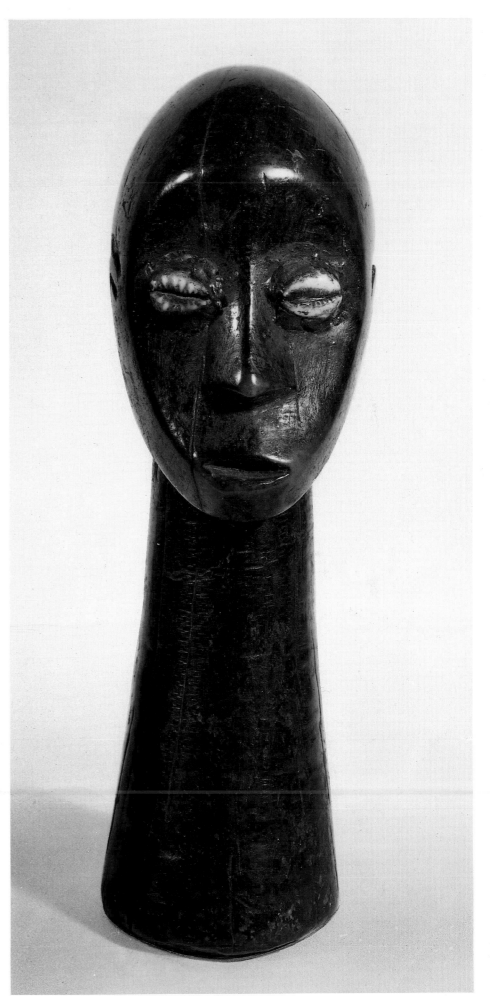

81

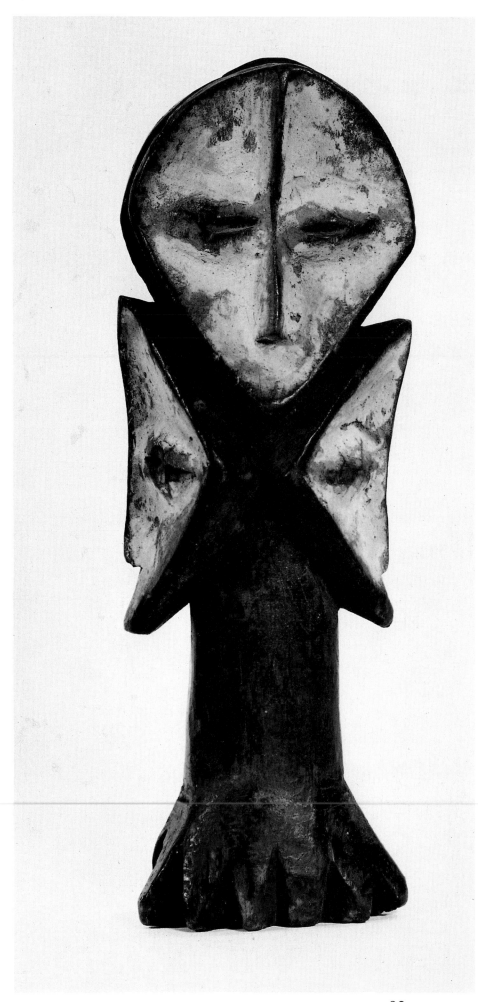

88. *Zaire, Lega*
Multi-headed Figure
Wood, pigment
H. 11 in.
National Museum of Natural History,
Smithsonian Institution Collection

Figures with multiple faces are frequently
included in Bwami initiation baskets, along with
a variety of other objects, both natural and man-
made. These multi-headed figures are also the
focus of a rite in which *kindi* initiates dance
together holding figures of the same type (fig.
16 and reciting aphorisms such as "Mr. Many
Heads has seen an elephant on the other side of
the large river." This saying refers to the all-
seeing power of the *kindi* elders, and is a warn-
ing against those who would contradict or
question their authority.

89. *Zaire, Lega*
Figure
Wood, fiber
H. 9½ in.
Yulla Lipchitz Collection

While the significance of a Lega work of art is
determined by its artistic context, some types
are consistently associated with negative or
positive ideas. Figures, for example, with holes
pierced throughout their bodies are associated
with the dispersal of red ants and, therefore,
evil. Disfigurement—like the lack of arms—is
also negative and usually refers to a transgres-
sion of the law. Referring to adultery, theft or
general misconduct, this figure was a didactic
device that taught the Bwami social and moral
code. (*See fig. 16.*)

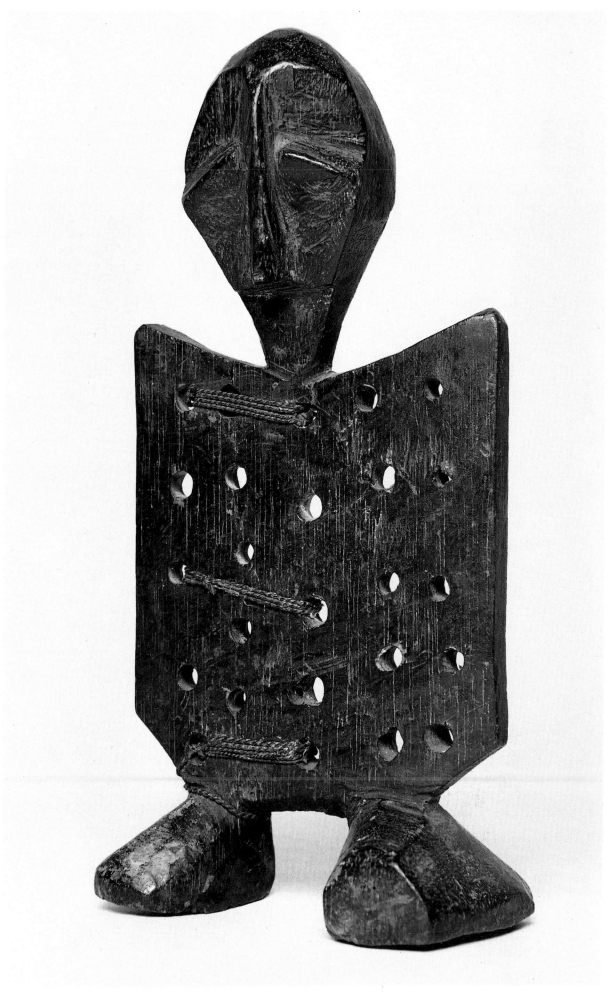

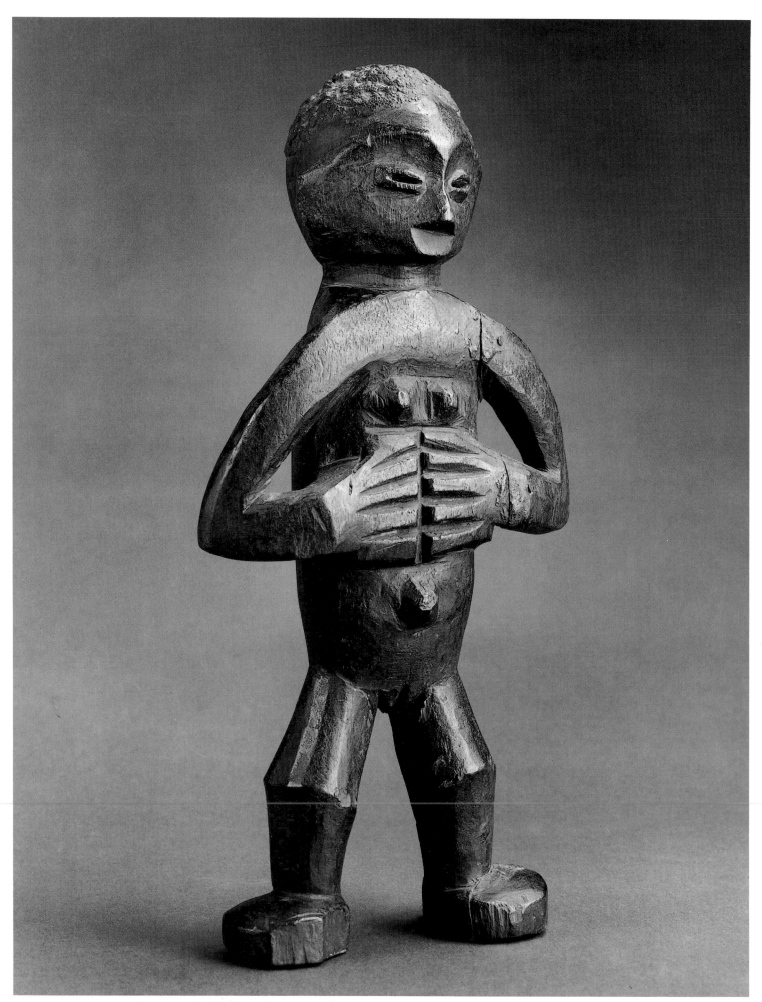

90. *Zaire, Lega*
Figure
Wood
H. 15½ in.
Max Granick Collection

Lega anthropomorphic figures represent a vast array of characters and ideas, all serving to reinforce the Bwami code of ethics. This figure, with the tension of the legs and the bowed configuration of the arms, is unique. Its large size and rare form indicate that it may have belonged to a senior *kindi*, or to a collectively-owned initiation basket. Grouped with other objects, it signified the corporate wisdom of the Bwami cult.

91. *Zaire, Lega*
Figure
Wood
H. 12¼ in.
Herbert Baker Collection
Palm Springs Desert Museum

The raised arms, bald head, and toothless gums of this figure identify it as an elder whose function is to arbitrate in community disputes and decisions. The meaning of a figure, however, is never constant in Lega art since it is modified by other objects. When this figure was grouped with others in the initiation basket, it could portray either a helpful or harmful elder. Such figures are connected with aphorisms, such as "What shoots up straight; I have arbitrated the sky; I have arbitrated something big."

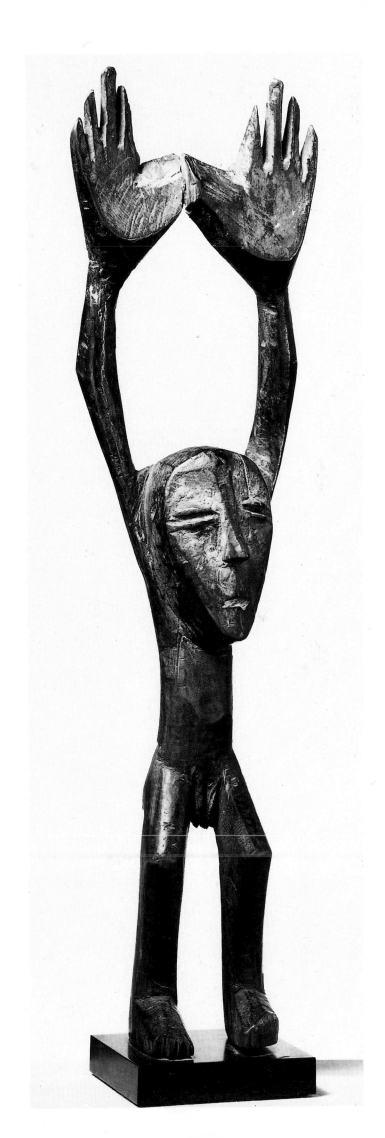

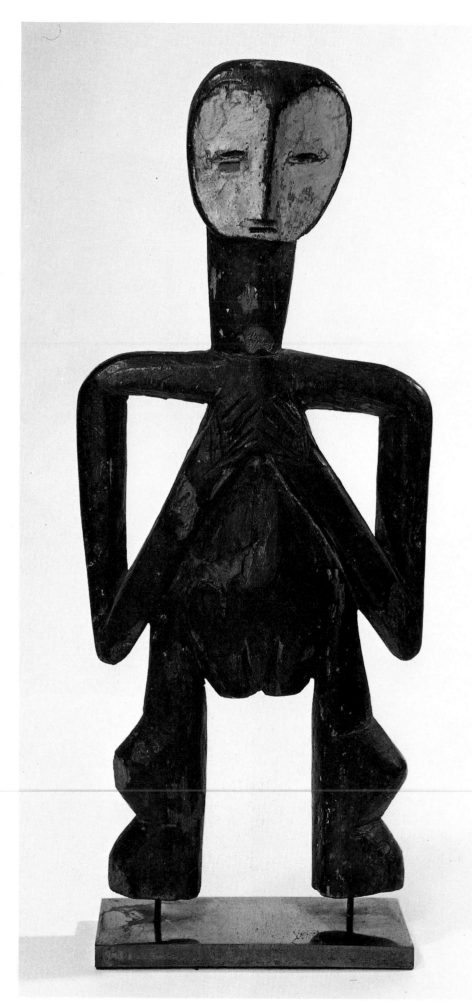

92. *Zaire, Lega*
Figure
Wood, pigment
H. 16 in.
Justin and Elisabeth Lang Collection

Most Lega art shares certain features such as a concave, heart-shaped face, and a schematized body with an asymmetrical composition. It is the endless variation of these elements that gives Lega art its greatness. The genius of this figure lies in the tension between rectilinear and curvilinear forms, negative and positive volumes, black and white coloring. The juxtaposition of competing shapes, and the placement of the head just slightly off center, bring this sculpture alive.

93. *Zaire, Lega*
Head
Ivory, cowrie shells, fiber
H. 5⅝ in.
Lawrence Gussman Collection

Studies in African aesthetics have revealed the close connection between physical and moral beauty in African language and thought. The Lega admire the hard, smooth surface of ivory as a substance, for it evokes the qualities of clarity, strength and durability. Heads carved out of ivory are owned exclusively by *kindi*, high-ranking elders who have attained a state of supreme wisdom. The bald skull and toothless mouth of this head suggest old age, while the cowrie shell eyes are a metaphor for the *kindi's* profound insight.

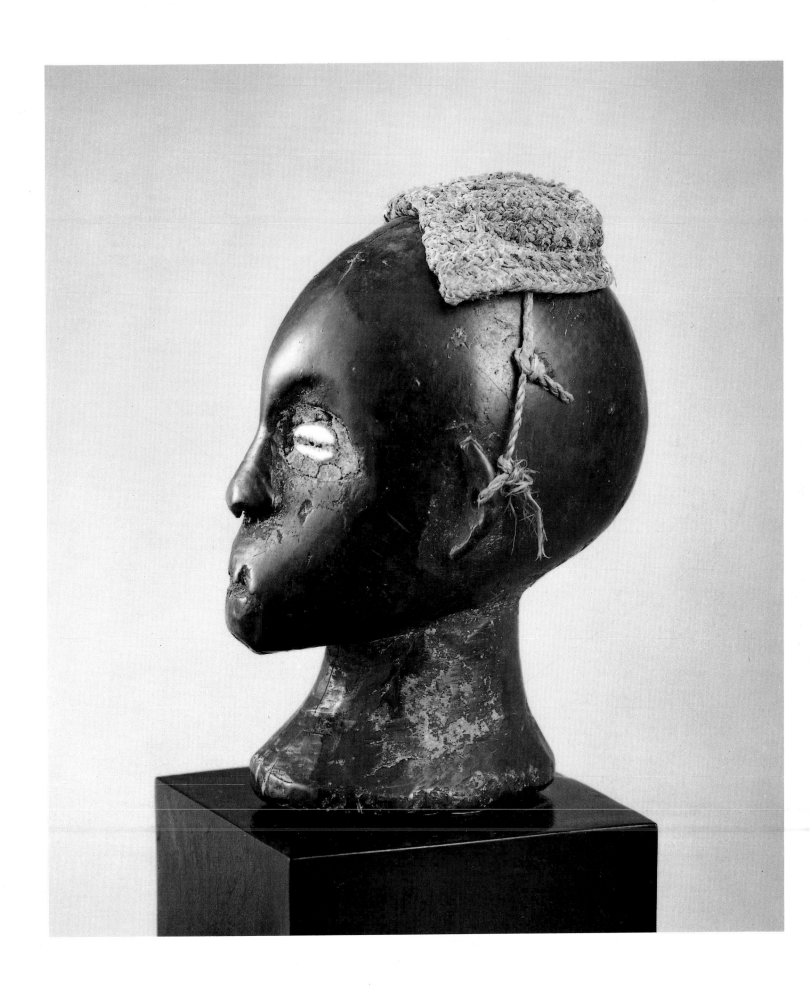

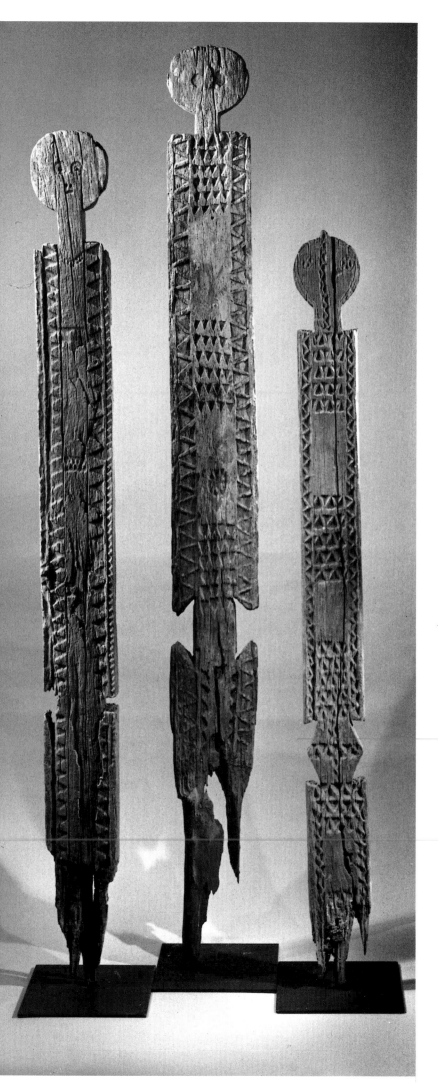
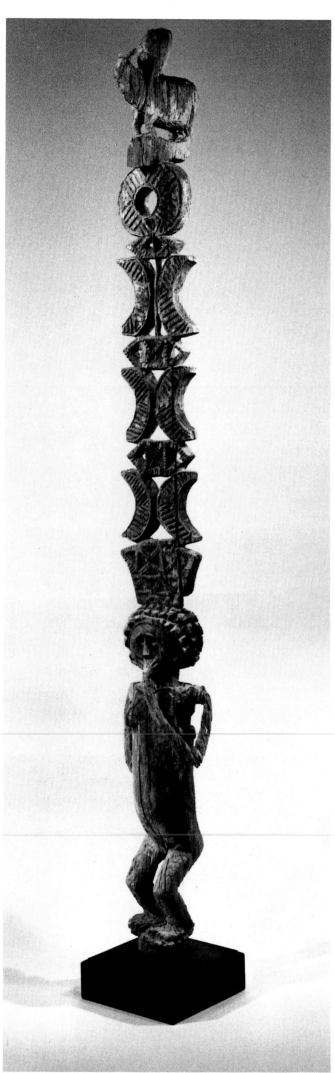

94. *Kenya, Giryama*
Commemorative Posts
Wood
A. H. 72 in. B. H. 65½ in. C. H. 58 in.
Robert and Nancy Nooter Collection

Along the coast of Kenya, members of the men's
Gohu society erect carved, wooden, anthropo-
morphic posts that represent ancestors. The
posts stand in front of the headman's house to
honor ancestors who have provided aid and
guidance to the living during periods of crisis.
The figures are rendered as simple, elegant
forms whose surfaces are incised with a rich
variety of geometric patterns that only hint at
human features. These may originally have
derived from interaction with Madagascar,
where there is a similar tradition of carved posts
(no. 97). (*Source for no. 94: Parkin et al. 1981.*)

97. *Madagascar, Sakalava*
Gravepost
H. 76 in. Wood
Robert and Nancy Nooter Collection

Grouped together on tombs, Malagasy grave-
posts resemble from afar slender towers silhou-
etted against the horizon. These delicate,
openwork structures, surmounted and sup-
ported by human and animal figures, signify
the passage from this world to the next. Here,
a female figure bears a child on her back and
emphatically covers her mouth in a gesture of
unknown meaning that implies both fear and
protection. Research suggests that these figures
are not portraits; the deceased was always com-
memorated by a sculpture of the opposite sex.
The groupings of figures may emphasize meta-
phorically the bond between men and women,
and the interdependence of individuals in soci-
ety. (*Source for no. 97: Urbain-Faublée 1963.
See fig. 10.*)

98. *Sudan, Bongo*
Commemorative Post
H. 22 in. Wood
Private Collection

At the death of a high-status individual, the
Bongo construct a stone mount where they place
an ensemble of wooden figures. The grouping
as a whole represents the spouse, children and
attendants of the deceased. In former times, the
superimposed rings on the supports of Bongo
posts referred to the number of animals a man
had killed during his lifetime. More recently,
they have become a generalized symbol of suc-
cess as a hunter or trader. In their simplicity
and reduction of the human form, Bongo posts
share certain formal similarities with the sculp-
ture of the entire Sudan belt. (*Source for no. 98:
Kronenberg 1960, 1963; Schweinfurth 1873.*)

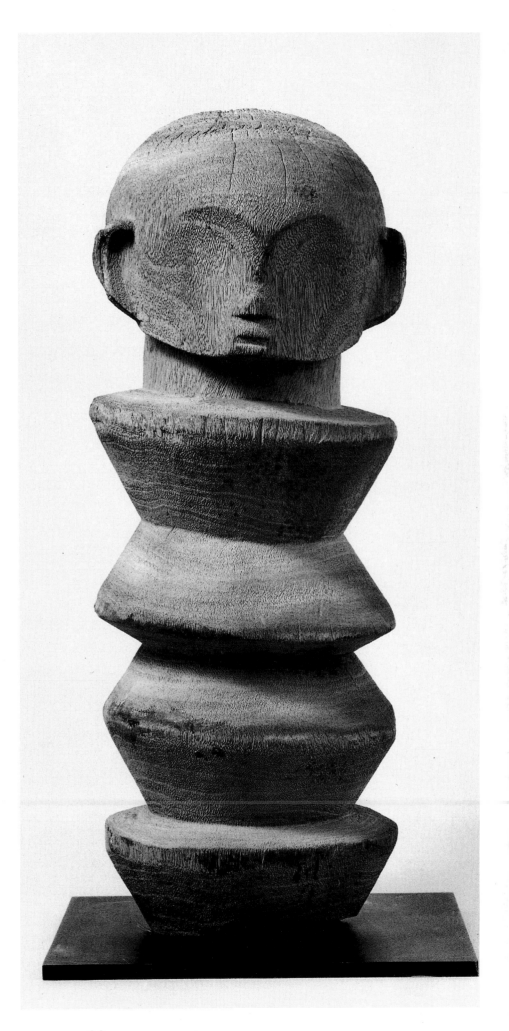

CHECKLIST OF THE EXHIBITION

1. Mother and Child Figure
 Mali, Bamana
 Wood
 H. 46½ in.
 Gustave and Franyo Schindler
 Collection
 Ill. page 31

2. Equestrian Figure
 Mali, Bamana
 Wood
 H. 52 in.
 Private Collection
 Ill. page 32

3. Mother and Child Figure
 Mali, Bamana
 Wood
 H. 45 in.
 Private Collection
 Ill. page 33

4. Mother and Child Figure
 Mali, Bamana
 Wood
 H. 43½ in.
 Private Collection
 Ill. page 34

5. Standing Male Figure
 Mali, Bamana
 Wood
 H. 33½ in.
 Private Collection
 Ill. page 34

6. Standing Female Figure
 Mali, Bamana
 Wood
 H. 52 in.
 Marc and Denyse Ginzberg
 Collection

7. Standing Figure
 Mali, Bamana
 Wood
 H. 46 in.
 Hélène and Philippe Leloup
 Collection

8. Figure
 Guinea/Sierra Leone, Toma
 Wood
 H. 44 in.
 Private Collection
 Ill. page 35

9. Mask: Dandai
 Guinea/Sierra Leone, Toma
 Wood, pigment, feathers, fiber,
 cloth, fur, hair, skin and
 aluminum
 H. 65 in.
 Harrison Eiteljorg Collection
 Ill. page 36

10. Cloaks and Headdresses for
 Wenilegagi Dancers
 Guinea/Sierra Leone, Toma
 Feathers, fabric
 A—Cloak H. 44 in.
 Headdress H. 22 in.
 B—Cloak H. 38 in.
 Headdress H. 26½ in.
 Harrison Eiteljorg Collection
 Ill. page 37

11. Mask
 Guinea/Sierra Leone, Toma
 Wood
 H. 22 in.
 Karob Collection, Boston
 Ill. page 38

12. Mask
 Guinea/Sierra Leone, Toma
 Wood, shell, horns, other materials
 H. 27 in.
 Mr. and Mrs. William W. Brill
 Collection
 Ill. page 38

13. Animal Mask
 Sierra Leone, Sherbro?
 Wood, fiber, other materials
 H. 14 in.
 Yale University Art Gallery, Gift of
 Mr. and Mrs. James M. Osborn
 for the Linton Collection
 Ill. page 39

14. Animal Mask
 Sierra Leone, Sherbro
 Wood
 H. 15 in.
 Private Collection
 Ill. page 40

15. Mask
 Sierra Leone, Sherbro
 Wood, pigment
 H. 13 in.

The May Weber Foundation
 Collection, Chicago, Illinois
Ill. page 41

16. Female Mask
 Sierra Leone, Sherbro
 Wood, pigment
 H. 13 in.
 Faith-dorian and Martin Wright
 Collection
 Ill. page 42

17. Female Figure
 Ivory Coast, Senufo
 Wood
 H. 14 in.
 Ernst Anspach Collection

18. Chameleon
 Ivory Coast, Senufo
 Brass
 L. 2¼ in.
 Anita Glaze Collection

19. Pair of Male and Female Figures
 Ivory Coast, Senufo
 Wood
 H. Male 12½ in., Female: 10¾ in.
 Private Collection

20. Figures
 Ivory Coast, Senufo
 Bronze
 A–H 1^{15}/$_{16}$ in. B. H. 1⅝ in.
 C–H. 3¾ in. D–H. 2⅜ in.
 Mr. and Mrs. Arnold Syrop Collection

21. Bracelet
 Ivory Coast, Senufo
 Bronze
 D. 4 in.
 Dorothy Brill Robbins Collection

22. Mask: Kpan
 Ivory Coast, Baule
 Wood
 H. 18½ in.
 Collection Hubert Goldet, Paris
 Ill. page 43

23. Mask: Goli Glin
 Ivory Coast, Baule
 Wood
 L. 48 in.
 Philip Ravenhill and Judith Timyan
 Collection

24. Mask: Kpan Pre
 Ivory Coast, Baule
 Wood
 H. 13½ in.
 Mr. and Mrs. Harold Rome
 Collection
 Ill. page 44

25. Mask: Kouassi Gbe
 Ivory Coast, Baule
 Wood
 H. 13½ in.
 Mr. and Mrs. Harold Rome
 Collection
 Ill. page 45

26. Commemorative Head
 Ghana, Akan
 Terracotta
 H. 9 in.
 Maurice Shapiro Collection
 Ill. page 46

27. Funerary Food Bowl
 Ghana, Akan
 Terracotta
 H. 10½ in.
 Genevieve McMillan Collection
 Ill. page 47

28. Commemorative Head
 Ghana, Akan
 Terracotta
 H. 14 in.
 The Chang Trust Collection
 Ill. page 48

29. Mother and Child Figure
 Ghana, Akan
 Terracotta
 H. 10 in.
 The Chang Trust Collection

30. Commemorative Head
 Ghana, Akan
 Terracotta
 H. 10 in.
 Jay and Clayre Haft Collection

31. Funerary Oil Lamp
 Ghana, Akan
 Terracotta, H. 6¾ in.
 Gerald and Leona Shapiro
 Collection

32. Antelope Head
 Ghana, Akan
 Terracotta
 H. 5 1/16 in.
 Ernest and Jeri Drucker Collection

33. Kola Bowl for Ifa
 Nigeria, Yoruba
 Wood
 H. 6¾ in.
 Jay and Clayre Haft Collection
 Ill. page 49

34. Ifa Divination Tapper
 Nigeria, Yoruba
 Ivory
 H. 13¾ in.
 Drs. Daniel and Marian Malcolm
 Collection
 Ill. page 50

35. Kola Bowl for Ifa
 Nigeria, Yoruba
 Wood
 H. 10½ in.
 Hammer Collection, Chicago
 Ill. page 51

36. Ifa Divination Tray
 Nigeria, Yoruba
 Wood
 D. 19 in.
 Drs. Daniel and Marian Malcolm
 Collection
 Ill. page 52

37. Ifa Divination Tapper
 Nigeria, Yoruba
 Ivory
 H. 9 in.
 Richard Faletti Collection

38. Kola Bowl for Ifa
 Nigeria, Yoruba
 Wood
 H. 17¾ in.
 Hammer Collection, Chicago

39. Ifa Divination Tray
 Nigeria, Yoruba
 Wood
 H. 15⅝ in.
 Dr. and Mrs. Robert Magoon
 Collection

40. Ifa Divination Bag
 Nigeria, Yoruba
 Cotton, beads
 H. 14¾ in.
 Mrs. Lester Wunderman Collection

41. Head for Royal Altar
 Nigeria, Benin
 Bronze
 H. 9 in.
 Private Collection
 Ill. page 53

42. Head for Caster's Altar
 Nigeria, Benin
 Terracotta
 H. 9 in.
 Private Collection
 Ill. page 54

43. Head for Chief's Altar
 Nigeria, Benin
 Wood
 H. 26½ in.
 Merton D. Simpson Gallery
 Collection
 Ill. page 55

44. Mask
 Nigeria, Ijo
 Wood
 H. 41¾ in.
 Junis and Burton Marcus Collection

45. Mask
 Nigeria, Ijo
 Wood
 H. 19½ in.
 Collection Delbanco

46. Mask
 Nigeria, Ijo
 Wood
 H. 14½ in.
 Ernst Anspach Collection

47. Mask
 Nigeria, Ijo
 Wood, metal
 H. 29 in.
 Private Collection

48. Mask
 Nigeria, Ijo
 Wood
 H. 13½ in.
 Drs. Daniel and Marian Malcolm
 Collection

49. Shrine Figure
 Nigeria, Urhobo
 Wood, pigment
 H. 81 in.
 William and Niki Wright Collection
 Ill. page 56

50. Shrine Figure
 Nigeria, Urhobo
 Wood, pigment
 H. 80 in.
 Mr. and Mrs. John N. Rosekrans,
 Jr. Collection
 Ill. page 57

SELECTED BIBLIOGRAPHY

Adamson, Joy
1957 "Kaya und Grabfiguren der Küstenbantu in Kenya," *Paideuma*, vol. 6, pp. 251–56.

Bastin, Marie-Louise
1982 *La Sculpture tshokwe*. Meudon.

Biebuyck, Daniel P.
1973 *Lega Culture: Art, Initiation, and Moral Philosophy Among a Central African People*. Berkeley.

Blackmun-Visona, Monica
1985 *Fokwe: A Lagoon Age-Grade Festival*. Paper read to the College Art Association, Los Angeles.

Bogaerts, H.
1950 "Bij de Basala Mpasu, de Koppensnellers van Kasai," *Zaire*, vol. 4, no. 4, pp. 379–419.

Ceyssens, Rik
1973– "Les Masques en bois des Kete du sud (région du
74 Kasai occidental, République du Zaïre)," *Africa-Tervuren*, vol. 19, no. 4, pp. 85–96; vol. 20, no. 1, pp. 3–12.

Clé, R.P.
1948 "Les Basala Mpasu; quelques aspects de leur vie," *Missions de Scheut*, vol. 5, pp. 120–22; vol. 6, pp. 143–47; vol. 10, pp. 246–49; vol. 11, pp. 269–71.

Cornet, Joseph
1982 *Art royal kuba*. Milan.

De Areia, M.I. Rodrigues
1978 "Le Panier divinatoire de Tshokwe," *Arts d'Afrique noire*, vol. 26, pp. 30–44.

Eberl-Elber, Ralph
1936 *Westafrikas letztes Rätzel: Erlebnisbericht über die Forschungsreise 1935 durch Sierra Leone*. Salzburg.
1937 "Die Masken der Männerbünde in Sierra Leone," *Ethnos*, vol. 2, pp. 38–46.

Ehrlich, Martha
n.d. *Zande Core Figurative Sculpture*. Unpublished m.s. in author's file since 1972.

Evans-Pritchard, Edward E.
1931– "The Mberidi (Shilluk Group) and Mbegumba (Basiri
32 Group) of the Bahr-el-Ghazal," *Sudan Notes and Records*, vol. 14, pp. 15–48; vol. 15, pp. 273–74.
1935 "Megalithic Grave Monuments in the Anglo-Egyptian Sudan and Other Parts of East Africa," *Antiquity*, vol. 9, pp. 151–60.

Fagg, William, and Pemberton, John
1982 *Yoruba: Sculpture of West Africa*. New York.

Foss, Perkins
1973 "Festival of Ohworu at Evwreni," *African Arts*, vol. 6, no. 4, pp. 20–27, 94.

1976 "Urhobo Statuary for Spirits and Ancestors," *African Arts*, vol. 9, no. 4, pp. 12–23, 89–90.

Fraser, Douglas
1974 "The Legendary Ancestor Tradition in West African Art," *African Art as Philosophy*, ed. by Douglas Fraser, pp. 38–54. New York.

Gaisseau, Pierre-Dominique
1954 *The Sacred Forest: Magic and Secret Rites in French Guinea*. New York.

Gallois-Duquette, Danielle
1979 *Dynamique de l'art bidjogo, Guinée-Bissau: Contribution à une anthropologie de l'art des sociétés africaines*. Ph.D. diss., University of Paris.

Gebauer, Paul
1979 *Art of Cameroon*. The Portland Art Museum, Portland, Oregon in association with the Metropolitan Museum of Art, New York.

Germann, Paul
1933 *Die Völkerstämme im Norden von Liberia: Ergebnisse einer Forschungsreise im Auftrage des Staatlich-sächsischen Forschungs-institutes für Völkerkunde in Leipzig in den Jahren 1928/29*. Leipzig.

Glaze, Anita
1981 *Art and Death in a Senufo Village*. Bloomington.

Henderson, Joe
1936 *For the Congo and Christ*. New York.
1944 Letter of May 10, 1944 with firsthand account of *mukish* and *akish*. Copies in files of The Museum of Cultural History, Los Angeles, and of the author.

Heuglin, Theodor von
1869 *Reise in das Gebiet des Weissen Nil und seiner westlichen Zuflüsse in den Jahren 1862–1864*. Leipzig.

Hildebrand, Eugen
1937 *Die Geheimbünde westafrikas als Problem der Religionswissenschaft*. Ph.D. diss., Leipzig.

Himmelheber, Hans
1960 *Negerkunst und Negerkünstler*. Braunschweig.

Horton, Robin
1965 *Kalabari Sculpture*. Lagos.

Huet, Michel
1978 *The Dance, Art and Ritual of Africa*. New York.

Huxley, Elspeth J.
1973 "The Challenge of Africa," *Exploring Africa and Asia*. Garden City.

Imperato, Pascal James
1983 *Buffoons, Queens and Wooden Horsemen: The Dyo and Gouan Societies of the Bambara of Mali*. New York.

Jackson, Henry C.
1954 *Sudan Days and Ways*. London.

Kronenberg, Andreas and Waltraud
1960 "Wooden Carvings in the South Western Sudan," *Kush*, vol. 8, pp. 274–81.
1963 "Die soziale Rolle der Jagd bei den Bongo," *Anthropos*, vol. 58, no. 3/4, pp. 507–519.

Kun, Nicolas de
1966 "L'Art lega," *Africa-Tervuren*, vol. 12, no. 3/4, pp. 69–99.

MacCormack, Carol P.
1980 "Proto-Social to Adult: A Sherbro Transformation," *Nature, Culture and Gender*, ed. by C.P. MacCormack and M. Strathern, pp. 95–118. Cambridge.
1982 "Art and Symbolism in Thoma Ritual Among the Sherbro, Sierra Leone," *Ethnologische Zeitschrift Zuerich*, 1980, no. 1, pp. 151–161.

Marden, Luis, and Moldvay, Albert
1967 "Madagascar: Island at the End of the World," *National Geographic*, vol. 132, no. 4, pp. 443–87.

Neyt, François
1981 *Arts traditionnels et histoire au Zaïre/Traditional Arts and History of Zäire*. Publications d'histoire de l'art et d'archéologie de l'Université catholique de Louvain, 29. Brussels.

Nooter, Polly
1984 *Luba Leadership Arts and the Politics of Prestige*. Master's thesis, Columbia University. New York.

Parkin, David; Sieber, Roy; and Wolfe, Ernie, 3rd.
1981 *Vigango: The Commemorative Sculpture of the Mijikenda of Kenya*. Bloomington.

Petherick, John
1861 *Egypt, the Soudan, and Central Africa*. Edinburgh.

Preston, George Nelson
1974 "Dynamic/Static," *African Art as Philosophy*, ed. by Douglas Fraser, pp. 54–58. New York.
1980 *Style and Context of Monolithic and Monoxylic Monuments of Sudan, Ethiopia, Kenya*. Paper read to the panel on Research in African Art of the Fifth Triennial Symposium on African Art, Atlanta, Georgia.

Schaefer, Stacy
1983 "Benin Commemorative Heads," *The Art of Power, the Power of Art: Studies in Benin Iconography*, ed. by Paula Ben-Amos and Arnold Rubin, pp. 71–78. Exhibition catalog: Museum of Cultural History, Los Angeles.

Schwartz, Nancy Beth A.
1972 *Mambila: Art and Material Culture*. Milwaukee Public Museum Publications in Primitive Art, 4.

Schweinfurth, Georg A.
1873 *The Heart of Africa: Three Years' Travels and Adventures in the Unexplored Regions of Central Africa, from 1868 to 1871*. 2 vols. London.
1875 *Artes Africanae: Abbildungen und Beschreibungen von Erzeugnissen des Kunstfleisses centralafrikanischer Völker/ Illustrations and Descriptions of Productions of the Industrial Arts of Central African Tribes*. Leipzig.

Seligman, Charles G.
1917 "A Bongo Funeral Figure," *Man*, vol. 17, no. 6, pp. 97–98.

Seligman, Charles G. and Brenda Z.
1932 *Pagan Tribes of the Nilotic Sudan*. London.

Timmermans, Paul
1967 "Les Lwalwa," *Africa-Tervuren*, vol. 13, no. 3/4, pp. 73–90.

Urbain-Faublée, Marcelle
1963 *L'Art malgache*. Paris.

Vansina, Jan
1955 "Initiation Rituals of the Bushong," *Africa*, vol. 25, no. 2, pp. 138–53.

Vogel, Susan Mullin
1977 *Baule Art as the Expression of a World View*. Ph.D. diss., New York University.
1981 *For Spirits and Kings, African Art from the Paul and Ruth Tishman Collection*. Exhibition catalog: Metropolitan Museum of Art, New York.

Williams, Drid
1968 "The Dance of the Bedu Moon," *African Arts/Arts d'Afrique noire*, vol. 2, no. 1, pp. 18–21, 72.

Wood, John George
1874- *The Natural History of Man: Being an Account of the Manners and Customs of the Uncivilized Races of Men*. London.
75

Wyndham, Richard
1936 *The Gentle Savage: A Sudanese Journey in the Province of Bahr-el-Ghazel, Commonly Called "The Bog."* London.

INDEX